BASEBALL
IN
BIRMINGHAM

BASEBALL
IN
BIRMINGHAM

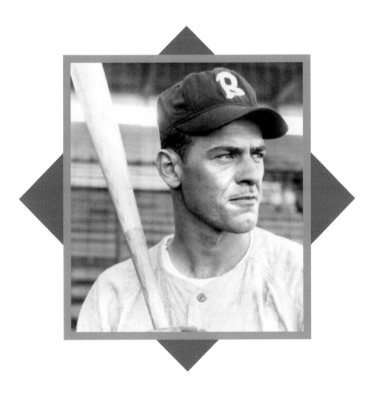

Clarence Watkins

ARCADIA
PUBLISHING

Copyright © 2010 by Clarence Watkins
ISBN 978-0-7385-6686-3

Published by Arcadia Publishing
Charleston, South Carolina

Printed in the United States of America

Library of Congress Control Number: 2009934723

For all general information contact Arcadia Publishing at:
Telephone 843-853-2070
Fax 843-853-0044
E-mail sales@arcadiapublishing.com
For customer service and orders:
Toll-Free 1-888-313-2665

Visit us on the Internet at www.arcadiapublishing.com

This book is dedicated to everyone who has followed the Barons over the years and can appreciate the memories a book like this can invoke. It is to those who have a warm heart for an old baseball glove and a 100-year-old baseball park. I also dedicate this to my grandfather Elmer Henry Putt, who gave me my love for baseball with his stories of games in St. Louis, Missouri, during the Great Depression years; I listened with him to games on the radio and talked about Willie Mays, Dusty Rhodes, and Dizzy Dean. It is only now that I have come to realize the impact my grandfather had on my life. To my wife, Carol, thank you for your patience during these months of preparation for this book and for your help in putting my thoughts into words and on paper.

CONTENTS

ACKNOWLEDGMENTS

No one plays a baseball game by himself and, likewise, no one can put together a book without the help of others.

First I must thank Skip Nipper of Nashville for giving me the idea that I could do this book. I thank the members of our Southern Association Conference who encouraged and supported the research of Southern baseball.

To David Brewer, the director of the Friends of Rickwood, thanks for giving me access to the archives of the Friends of Rickwood and answering many, many questions.

Thank you to Jonathan Nelson and his staff of the Birmingham Barons, who also provided much information about the past and present. Also thanks go to Joe DeLeonard, Mickey Newsome, Lamar Smith, Chuck Stewart, and others who helped me locate pictures and shared their memories.

INTRODUCTION

Having lived all around the Southeast over the past 50 years, I can now make some general observations about minor-league baseball. No matter the size of the city or the level of the league the team played in, certain things have happened.

Every team has had a golden age or a time to produce a dynasty. Each team produced its share of major-league talent. Each can lay claim to a member of the Hall of Fame who came through their team. Every team produced characters of the game: an owner, manager, player, vendor, or fan that made the game more interesting and fun to watch.

Every fan will tell you about the old ballpark and how unique and grand it was. But only Birmingham, Alabama, had what was arguably the best minor-league ballpark in the nation. When Rickwood Field was built by Rick Woodward in 1910, there were only three major-league ballparks that were made of concrete and steel: Forbes in Pittsburgh, Shibe in Philadelphia, and Comiskey in Chicago. The other 13 major-league teams were still playing in wooden ballparks from the last century. With the 1928 face-lift and additions, we have the Rickwood we know today.

If Rickwood had gone the way of most old ballparks, the victim of fire, progress, and increased real estate values, we would no doubt be studying the park as one of the classics. But somehow, with a bit of luck, the slow movement of politics, and a few fans who really cared and did something about it, Rickwood still stands today.

We are coming to a time when we will celebrate the 100-year anniversary of Rickwood Field. It is the leading lady of Birmingham baseball—the star that did not go on to the majors. We study the history of baseball in Birmingham with Rickwood Field as the constant, the North Star to guide us from the past to the future. You did not have to have grown up in Birmingham, attending games at Rickwood, to love and appreciate this grand old park. Rickwood not only evokes memories for locals but helps us all remember Russwood, Ponce de Leon, Hartwell, and Sulphur Dell.

Once a year, the present-day Birmingham Barons come back to Rickwood Field to play one game, a game to remember and honor one particular era in Barons baseball. It is this game, the Rickwood Classic, that gives the modern-day fan and ballplayer the ability to go back into the past, even if it is just for one game. He or she can experience the park as the greats of the national game did over the past 100 years.

Rickwood Field is a time machine for baseball fans. You can appreciate the absence of playgrounds and electronic scoreboards. You can view the game without the modern-day distractions. Then after the game, you can go onto the field and see the park from the players' perspective. Rickwood Field is not just an old ballpark but a living museum. Just as scholars study an old artifact, we can come to appreciate the social changes that happened there in 1964 and remember what "every other Sunday" meant. Unlike relics in a museum

roped off from the public or protected by glass cases, Rickwood is a relic you can touch, smell, and walk on.

Rickwood also gives us the opportunity to experience the absence of change. If we go back to the old neighborhood we grew up in, we find it has been remodeled beyond recognition or even torn down. The school we went to is all boarded up and doomed for demolition. We know that the only constant in our lives is change. But then we come to Rickwood, and change must be left outside the gate. It is the late 1940s at Rickwood Field. Manager Fred Walters's office in the home team locker room is much the way it was then. The advertisements on the outfield walls tell us we have gone back in time. At Rickwood, you talk about baseball without using words like steroids, free agent, union, and drug test.

Depending on your interest, there are places you must visit. If you love golf, you will go to Augusta. If the Civil War consumes you, then you must go to Gettysburg. That is what Rickwood is becoming to baseball fans, the mecca to which you must make a pilgrimage to connect the past with the present. This book is about the owners, the managers, and the players of baseball and how they impacted the games played on and off the field at Rickwood. Even though the Barons play their games today in the state-of-the-art Regions Park, we still remember Rickwood Field.

THE OLD

SOUTHERN LEAGUE

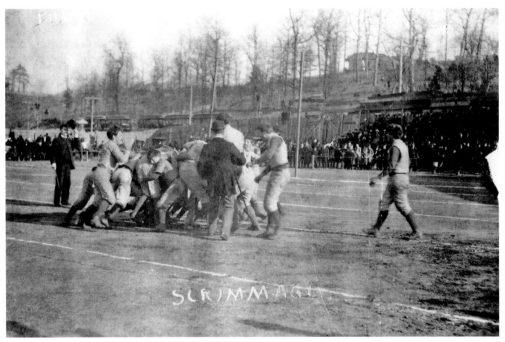

Lakeview Park was the original baseball field where the Barons played. This photograph of the first Alabama/Auburn footfall game gives a glimpse of the grandstand on the first-base line. Most people came to the park by streetcars, visible in the background. Also notice the horse and buggies parked along the first-base line, a very popular way to view a game in the days before automobiles. Today a plaque marks the location of Lakeview Park, which remembers it as only the site of the first Alabama football game and not the home of the Birmingham Barons. (Courtesy of Birmingham Public Library.)

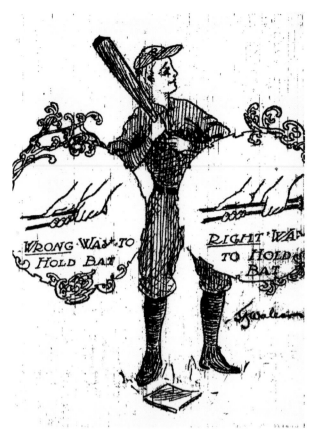

This early drawing on how to hit a baseball was part of a full two-page advertisement that ran in an early Birmingham newspaper. Baseball was the national pastime. The advertisement also talked about how to pitch. It modeled the latest in baseball uniforms. Notice the batter's hands, which are held apart, similar to the style used by Ty Cobb. (Author's collection.)

Blach's department store was a prominent retailer in Birmingham for many years. The picture shows the grandstand of Lakeview Park behind home plate. Also notice the very stylish uniforms of the Blach's company team. A clothier such as Blach's could only outfit his team in the very best. (Courtesy of Birmingham Public Library.)

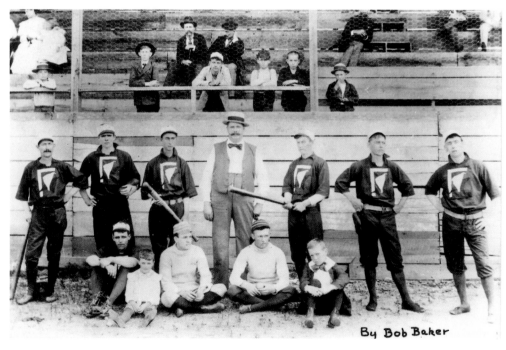

By Bob Baker

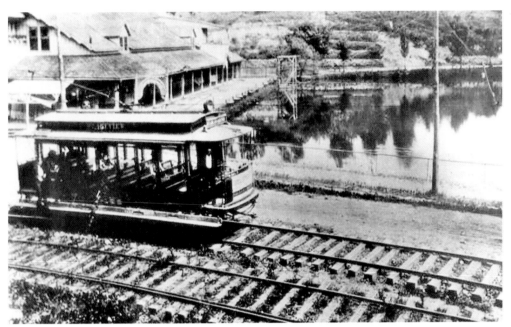

Well into the 20th century, trolleys or streetcars were the primary mode of transportation to the ballpark. This Lakeview Trolley shuttled fans from downtown to the game. To keep fans from coming to a game cancelled by rain, a large baseball was strung on cables across a prominent street in downtown Birmingham. If a game was to be played that day, the ball was placed in the middle of the street, easily seen by all. (Courtesy of Friends of Rickwood.)

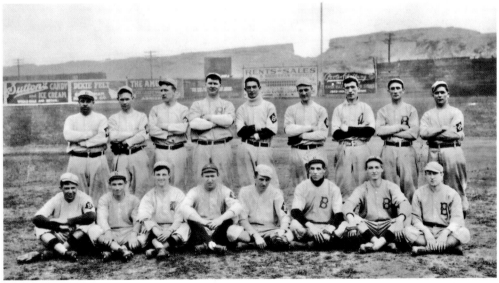

This is one of the few known photographs of West End Ballpark, also knows as the "Slag Pile." The mountain of slag (a by-product of making steel) can be seen beyond the outfield wall. Fans unwilling to purchase a game ticket would sit on top of the slag pile to observe the game. (Courtesy of Friends of Rickwood.)

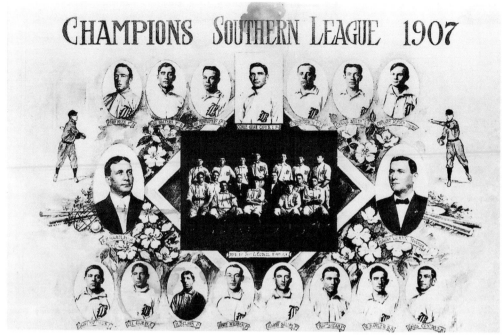

This picture of the 1907 champions is somewhat misleading. The Barons under the leadership of Harry Vaughn had won the Southern Association Championship in 1906. This photograph honoring the 1906 team may be implying that they are the reigning champions through the 1907 season until someone dethrones them at the end of the season in 1907. (Courtesy of Woodward family.)

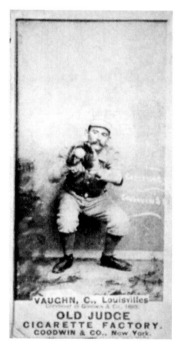

Harry Vaughn was one of the true pioneers in the 1880s of professional baseball. Also known as "Farmer" Vaughn, he was a catcher for several of the early professional teams, including Louisville and Cincinnati. Notice the early baseball card of Vaughn wearing gloves on both hands. On his right hand is a very early-style glove called the workman glove, and on his throwing hand is a fingerless glove, which was made to throw the ball and made it easier to catch with both hands. After his time in the majors, he came to Birmingham to play in 1903. In 1904, he became manager and led Birmingham to a championship in 1906. In 1908, Carlton Molesworth replaced Vaughn as manager in mid-season. (Author's collection.)

Harvey "Ginger" Clark had a brief stint with Cleveland in 1902, with a perfect record of 1-0. In 1906, Ginger Clark was part of an unprecedented trio of hurlers with Irwin Wilhelm and Arthur Ragan. All three were 20-game winners for one minor-league team, certainly something never to be seen again. (Courtesy of Friends of Rickwood.)

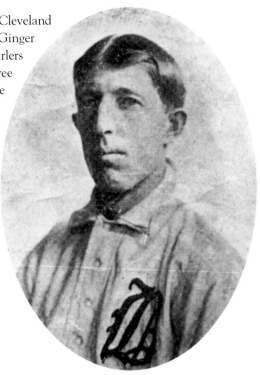

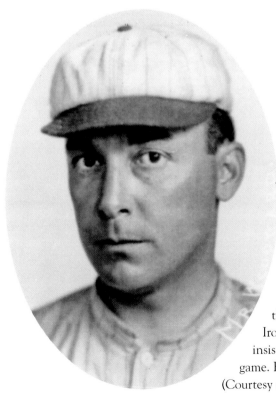

Rick Woodward had always fancied himself a baseball player. He played on his college team at Sewanee (University of the South), and he managed the Woodward Iron Company team. Woodward sometimes insisted on throwing the actual first pitch of the game. He was a true fan of the game in every way. (Courtesy of Carlton Molesworth III.)

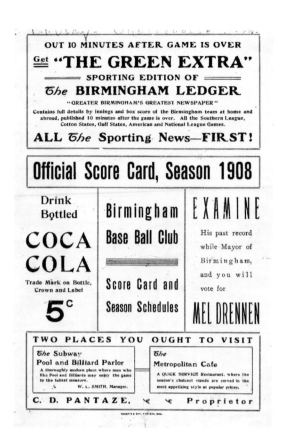

OUT 10 MINUTES AFTER GAME IS OVER

Get **"THE GREEN EXTRA"**

═══ SPORTING EDITION OF ═══

The **BIRMINGHAM LEDGER**

"GREATER BIRMINGHAM'S GREATEST NEWSPAPER"

Contains full details by innings and box score of the Birmingham team at home and abroad, published 10 minutes after the game is over. All the Southern League, Cotton States, Gulf States, American and National League Games.

ALL *The* Sporting News—FIRST!

Official Score Card, Season 1908

| Drink Bottled **COCA COLA** Trade Mark on Bottle, Crown and Label **5**ᶜ | **Birmingham Base Ball Club** ──── Score Card and Season Schedules | **EXAMINE** His past record while Mayor of Birmingham, and you will vote for **MEL DRENNEN** |

TWO PLACES YOU OUGHT TO VISIT

| *The* Subway **Pool and Billiard Parlor** A thoroughly modern place where men who like Pool and Billiards may enjoy the game to the fullest measure. W. L. SMITH, Manager. | *The* **Metropolitan Cafe** A QUICK SERVICE Restaurant, where the season's choicest viands are served in the most appetizing style at popular prices. |

C. D. PANTAZE, ✿ ✿ **Proprietor**

This is a rare program from the Barons playing a game at West End Park (the Slag Pile). Notice that advertising has always been a big part of baseball. The top advertisement is for the *Green Extra*, a sports edition of the *Birmingham Ledger*, a defunct newspaper. (Courtesy of Woodward family.)

In 1907, Harry "Buttermilk"" Meeks became the first Baron to lead the Southern Association in hitting with a .340 average. Harry was very popular around town. He ran a bowling alley in the off-season and played first base for the Birmingham Southern College baseball team in the spring. Collegiate rules were a little loose back then. (Courtesy of the Woodward family.)

THE OLD SOUTHERN LEAGUE

Bill McGilvray played five seasons for the Birmingham Barons. He was a gifted first baseman and a perennial .300 hitter. Bill's major-league career consisted of two games in 1908 with the Cincinnati Reds. The 1910 program stated, "In the wintertime Bill buys his chewing tobacco in Denver." Bill died at the age of 69 in Denver, Colorado. (Courtesy of Carlton Molesworth III.)

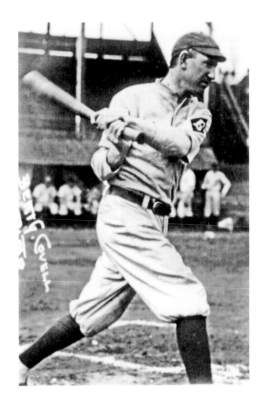

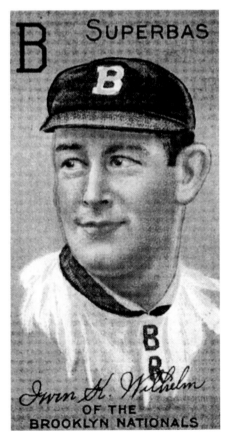

Irwin Wilhelm twice pitched for the Birmingham Club. His first tour of duty was 1901 and 1902, and he managed the club in 1902. After several seasons with the Boston Beaneaters, Wilhelm returned to Birmingham to post back-to-back 20-plus-win seasons in 1906 and 1907. The highlights of his second tour in Birmingham included a perfect game against the Montgomery Club on July 9, 1906. Wilhelm's nickname in the majors was "Kaiser" Wilhelm, but in Birmingham, for some forgotten reason, he was known as "Little Eva." On September 1, as the season was winding down, Wilhelm began a string of 55 scoreless innings. This record included a wide range of pitching performances. It started with a relief appearance and ended with Wilhelm pitching both games of a doubleheader on the last day of the season, certainly a record not to be broken. His fine pitching at Birmingham in 1907 helped earn Wilhelm a spot with Brooklyn in the majors for the 1908 season. (Author's collection.)

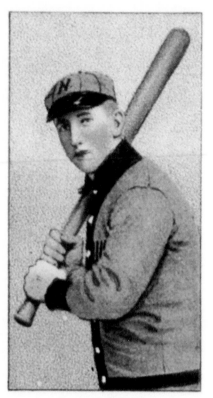

ELLAM, NASHVILLE

Roy Elam holds the record of playing the most games as a Baron. From 1909 until 1915, he played in 911 games and was a fine shortstop and a team MVP. Tragically Roy was killed by a 150-pound weight falling from a fire escape on October 28, 1948, in his hometown of Conshohocken, Pennsylvania. (Author's collection.)

Longtime Baron Roy Elam is shown here receiving the MVP award, an annual award voted on by fans. The award was a silver bat and ball. Roy's popularity can be attested to by the standing ovation he received when returning to Rickwood Field as a member of the Nashville Vols in 1916. (Courtesy of Friends of Rickwood.)

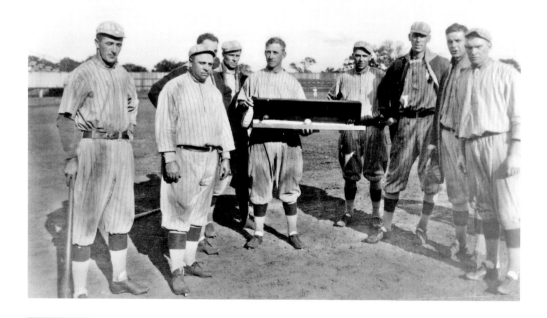

2

RICK BUILDS
A REAL BALLPARK

The owner of the Barons, Rick Woodward, was like a lot of men in his day—a frustrated baseball player. For the average young man, the inability to play baseball at the professional level is heartbreaking. But he learns to get over it and becomes a fan of the game. Rick Woodward was the son of a wealthy steel tycoon, so he took his love of baseball to the next level and bought the local team. Woodward did not just sit back and let the baseball people run his team; he got in the middle of everything. He was not satisfied with just throwing out a ceremonial first pitch—he had to throw out the first pitch in full uniform. Woodward got into fistfights with umpires, and his managers sometimes felt he was interfering with their job. (Courtesy of Friends of Rickwood.)

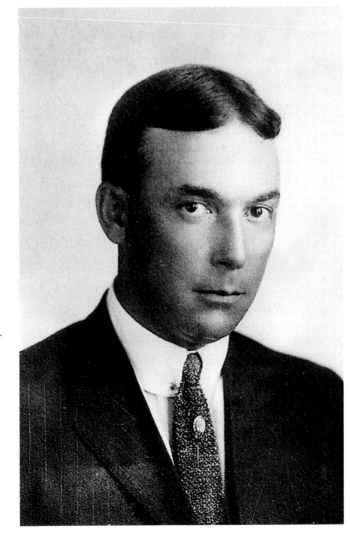

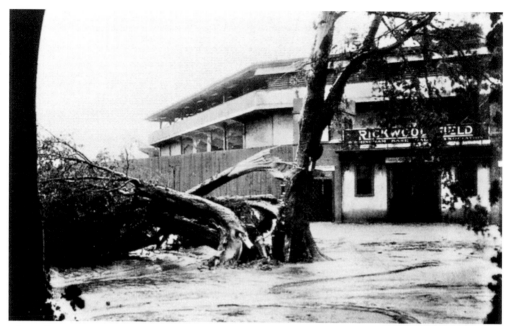

This photograph shows Rickwood after a storm in 1919 did considerable damage to the ballpark. It shows what the front entrance looked like before the 1928 remodeling. (Courtesy of Birmingham Public Library.)

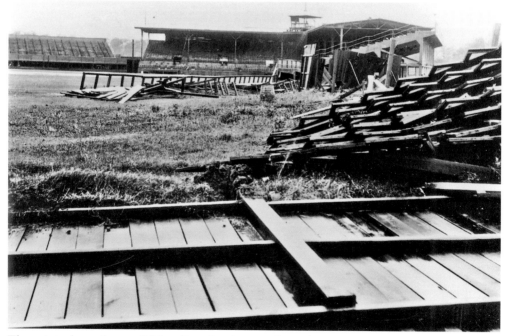

The original wooden outfield wall took a beating from the 1919 storm. It was replaced by a concrete wall in the 1928 remodel. That wall remains today as the outer wall securing the park. (Courtesy of Birmingham Public Library.)

RICK BUILDS A REAL BALLPARK

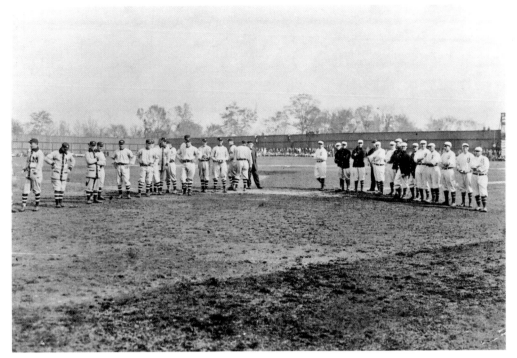

This is an early photograph of the Birmingham Barons and the Montgomery Climbers lining up before the start of a game. This could very well be the first game at Rickwood, although the size of the crowd in the outfield area suggests just another game. Also, the woolen team jackets worn by both teams make one think of an early April game at the beginning of a new season. (Courtesy of Friends of Rickwood.)

Rafael "Mike" Almeida and Armando Marsans were the first Cubans to play baseball in the major leagues in the modern era. Both signed with the Cincinnati Reds in 1911. Almeida, shown here, played third base for the 1912 Barons, helping them win the championship that year. (Courtesy of Carlton Molesworth III.)

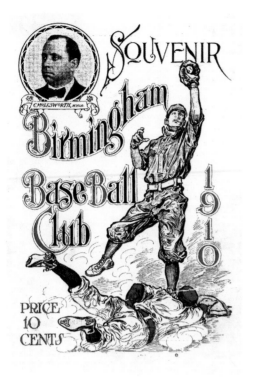

This is the program cover from the first game at Rickwood Field on August 18, 1910. It is only the second known copy of that historic program to surface. In 1985, an elderly lady loaned Art Clarkson her copy, but it did not have the front cover. The author expresses thanks to the Woodward family for donating this program to the Friends of Rickwood. (Courtesy of Woodward family.)

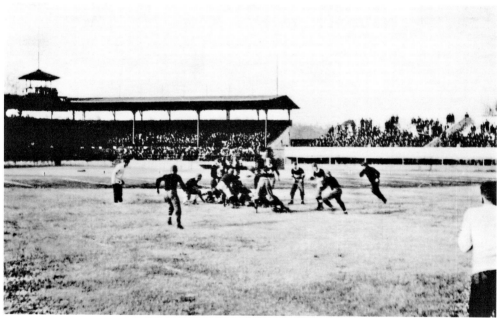

Rickwood was more than just a baseball park. Until Legion Field was built, many high school and college football games were held there. Rickwood Field was the site of baseball games for the industrial leagues, college, and high school teams. The circus was a regular visitor to Rickwood in the first half of the century. (Courtesy of Birmingham Public Library.)

RICK BUILDS A REAL BALLPARK

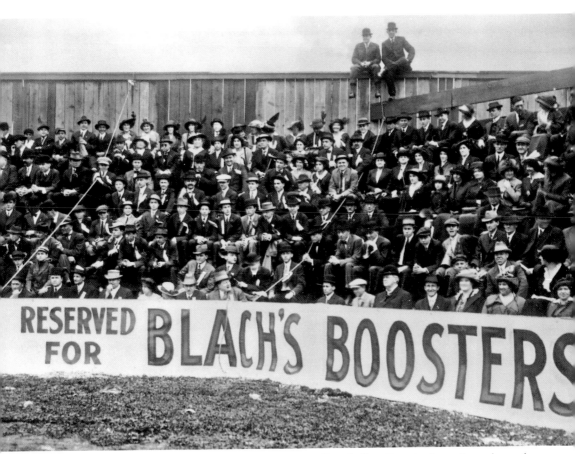

Blach's department store owners have been boosters of baseball in Birmingham since the early days. Page 10 shows their company team. Blach's provided a special section for employees and friends to watch the games. As late as the 1950s, Blach's gave Baron players new suits for hitting home runs. (Courtesy of Birmingham Public Library.)

It may be hard to imagine, but Carlton Molesworth started his baseball career in the Washington Senators organization as a pitcher. About 5 foot, 6 inches tall (which was short for a pitcher even at the dawn of the 20th century), Molesworth did manage to get in four games with Washington in 1895. (Author's collection.)

MOLESWORTH, BIRMINGHAM

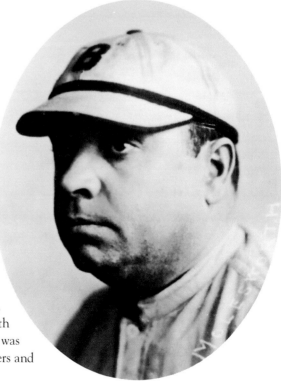

Before coming to Birmingham in 1906, Carlton Molesworth played for Chattanooga and Montgomery. In 1905, Molesworth won the batting title with Montgomery with a .312 average. He was affectionately called "Moley" by his players and friends. (Courtesy of Woodward family.)

Bob Messenger's full name was Charles Walter Messenger. It was somewhat unusual to find someone nicknamed Bob whose given name was not Robert. His workup in the 1910 program states he was the fastest runner on the team. Bob never had more than a "cup of coffee" with a major-league team of four different seasons. He did manage to play professional baseball for 15 years, of which 5 years were in the Southern Association. (Courtesy of Carlton Molesworth III.)

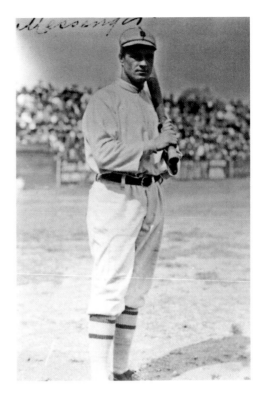

Arthur Marcan, the second baseman on the 1910 team, was known for outguessing the opposing team when it came to trick plays and base runners stealing. His nicknames were "Lil" and "the Heady One." (Courtesy of Carlton Molesworth III.)

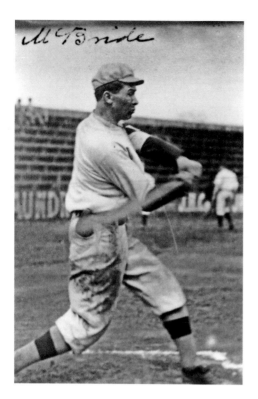

Clyde McBride played left field for six seasons for the Barons, or as it was said in 1910, he was the keeper of the left-field garden. Clyde's first year with the Barons was 1910, the season Rickwood Field was dedicated. (Courtesy of Carlton Molesworth III.)

Rick Woodward developed a working relationship with Pittsburgh Pirates owner Barry Dreyfuss. In 1920, the Barons had the good fortune to have Pie Traynor sent to Birmingham to gain a little more experience. Traynor's season with the Barons was outstanding. He was a powerful hitter with a strong throwing arm. This photograph shows Traynor (right) with teammate Johnny Gooch. Pie Traynor was the first former Baron to be enshrined in the Baseball Hall of Fame. (Courtesy of Friends of Rickwood.)

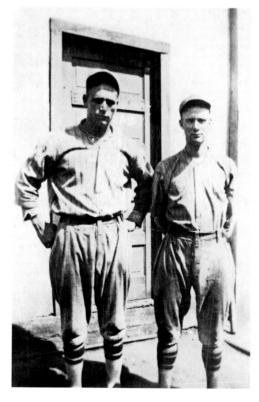

RICK BUILDS A REAL BALLPARK

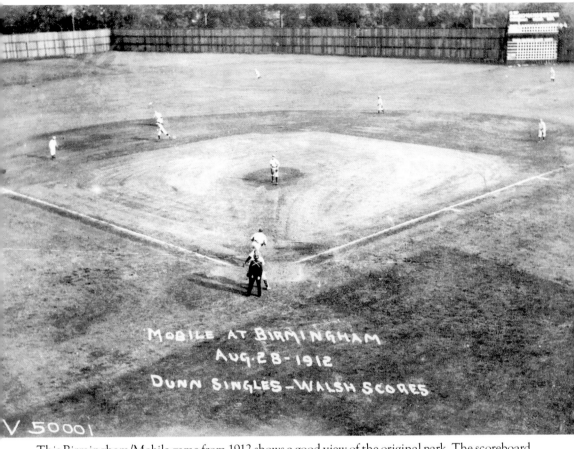

This Birmingham/Mobile game from 1912 shows a good view of the original park. The scoreboard is in right field. The top sections of the scoreboard gave the line score of the current Barons game, and the bottom half kept up with scores from other Southern Association games. This original fence at over 400 feet made it almost impossible for anyone to hit a home run out of the park. The picture caption—"Walsh Scores"—tells that the runner taking off from second base is Dee Walsh, an infielder for the Mobile Sea Gulls. The batter who knocks him in is Joe Dunn, the catcher for Mobile. (Courtesy of Carlton Molesworth III.)

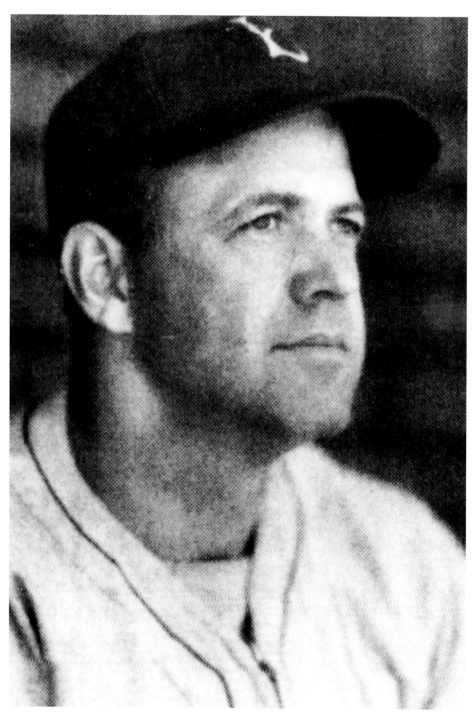

Burleigh Grimes pitched for the Barons for three years (1914–1916). He was known for his fiery temper—he once threw a pitch at a batter in the on-deck circle. Grimes was another of the players the Pirates sent to Birmingham. Elected to the Hall of Fame in 1964, Grimes led the Barons to the 1914 Southern Association Championship. (Courtesy of Birmingham Barons.)

RICK BUILDS A REAL BALLPARK

Today the purpose of the minor leagues is to train players for the major leagues. Few players return to the minors to play for any extended period. This was not so in the first half of the 20th century. After his major-league career was over, William Foxen came to Birmingham and played three years for the Barons. (Courtesy of Carlton Molesworth III.)

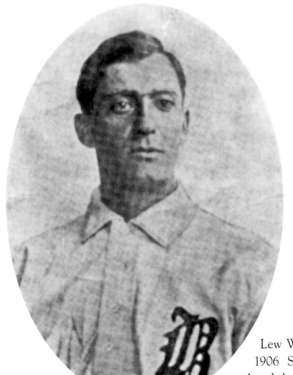

Lew Walters was the second baseman for the 1906 Southern Association Barons. Walters played three years for the Barons and one year for Memphis. (Courtesy of Woodward family.)

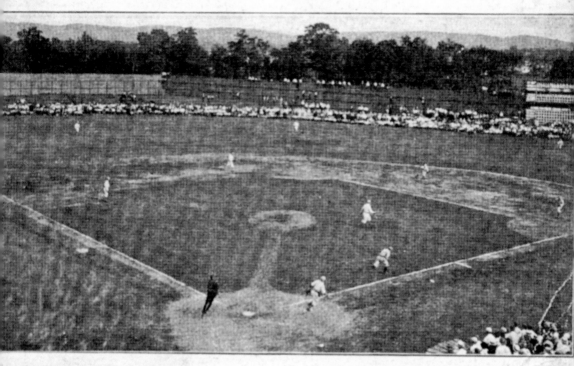

VIEW OF RICKWOOD BASE BALL PARK

This is a very early postcard of the ball field. Notice the fans sitting on top of the fence. Also notice that there is only one umpire on the field. This was probably an opening-day game suggested by the overflow crowd of fans in the outfield. (Courtesy of Woodward family.)

RICK BUILDS A REAL BALLPARK

The Roaring Twenties
and the Depression Years

With the end of the 1927 season, Rick Woodward had two goals to accomplish. The first was a major renovation to his ballpark. Rickwood Field was 17 years old, and more seating was needed. Atlanta and Nashville had new ballparks built in the past few years, and Birmingham needed to keep up. Second, and just as important, Woodward needed to assemble a competitive winning team. It was not uncommon in the 1920s or 1930s for a minor-league team to purchase contracts of proven major-league players to help place the team in contention for the championship; Birmingham did just that. (Courtesy of Friends of Rickwood.)

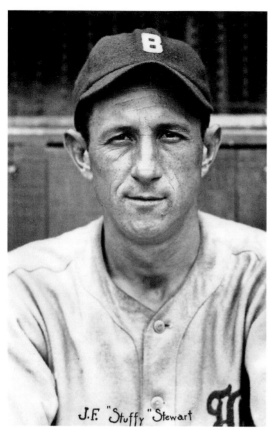

J.F. "Stuffy" Stewart

In eight seasons in the major league, Stuffy Stewart only played in 50 or more games in two seasons. But for Birmingham from 1920 to 1928, he was a hitting machine. Stewart led the Barons in runs scored three of the seven years he played in Birmingham. Stewart also led the 1928 team with 61 stolen bases. He was the stolen-base leader six out of seven seasons with the Barons. Stewart also managed the Barons in 1923–1924. (Courtesy of Chuck Stewart.)

Everett "Yam" Yaryan was the Barons' catcher from 1925 to 1929. He came to Birmingham from the Memphis Chicks. Many of the old-timers consider Yaryan to be the best right-handed hitter Birmingham ever had. Later Yaryan would manage and catch for a young Birmingham pitcher, Virgil Trucks, at Andalusia as he set many league records on his way to the major leagues. (Courtesy of Friends of Rickwood.)

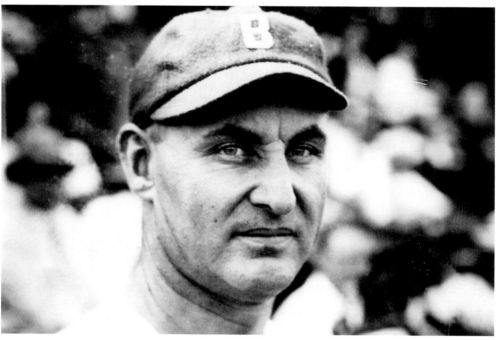

A pitching oddity was performed by Dick Ludolph and the Barons on May 10, 1930. During the first three innings of the game, each Barons player was credited with a putout. It went like this: first inning—left fielder, shortstop, pitcher; second inning—catcher, center fielder, third baseman; third inning—first baseman, right fielder, second baseman. (Courtesy of Birmingham Barons.)

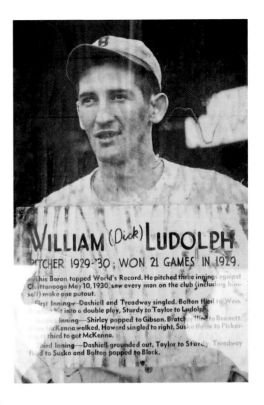

WILLIAM (Dick) LUDOLPH.
PITCHER 1929-'30 ; WON 21 GAMES IN 1929.

This Baron topped World's Record. He pitched three innings against Chattanooga May 10, 1930, saw every man on the club (including himself) make one putout.

First Inning—Dashiell and Treadway singled. Bolton flied to Weis. Hit into a double play, Sturdy to Taylor to Ludolph.

Second Inning—Shirley popped to Gibson. Bratcher flied to Bennett. McKenna walked, Howard singled to right. Susko throw to Pickering to third to get McKenna.

Third Inning—Dashiell grounded out, Taylor to Sturdy. Treadway flied to Susko and Bolton popped to Black.

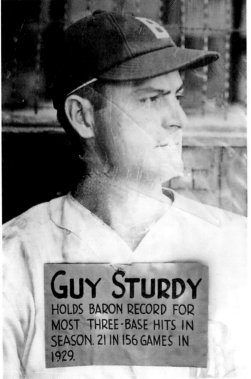

GUY STURDY
HOLDS BARON RECORD FOR MOST THREE-BASE HITS IN SEASON. 21 IN 156 GAMES IN 1929.

Guy Sturdy played professional baseball for 21 years. He played two years for Birmingham in 1929 and 1930. Sturdy led the American League in pinch hits playing for the St. Louis Browns in 1928. (Courtesy of Birmingham Barons.)

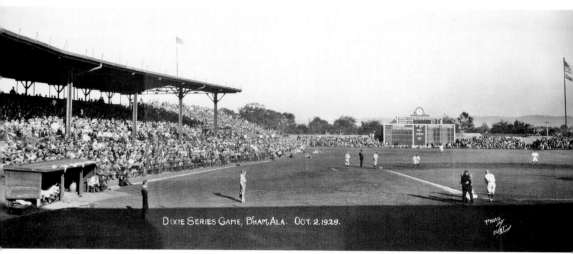

DIXIE SERIES GAME, B'HAM, ALA. OCT. 2, 1929.

This panoramic view of the 1929 Dixie Series reveals a lot about the ballpark and the game. There are no lights on the roof of the stands, and the old dugouts are in place. These dugouts had tunnels to the dressing rooms and were closer to home plate. They were also at field level and not below field level like the current ones. The newly constructed scoreboard towers over left field. Only the steel-and-concrete base remains to remind one of where this scoreboard stood. Also notice two American flags flying over the ballpark. The larger flag in center field also flies the championship banner for 1928. (Courtesy of Glynn West.)

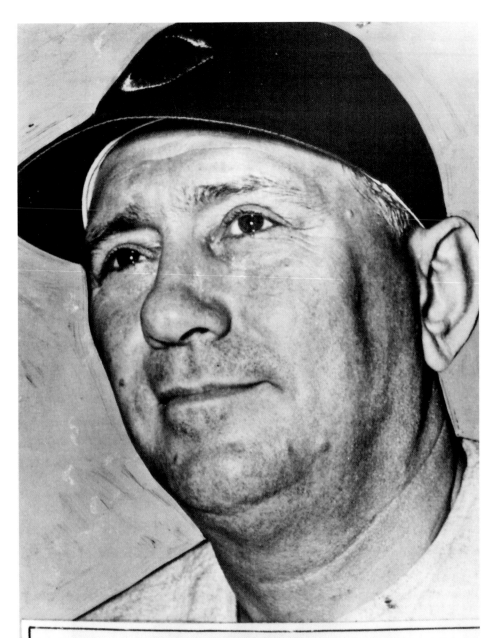

John (Flip) Neun

First baseman. Holds record for most consecutive hits by Baron, 11 in 1923. Stole 82 bases in two years. Batted .329 and .320.

On May 21, 1927, Johnny Neun completed the seventh unassisted triple play in major-league history while playing for the Cleveland Indians, a difficult feat for a first baseman. Johnny Neun was always a .300 hitter for Birmingham in 1922 and 1923. (Courtesy of Friends of Rickwood.)

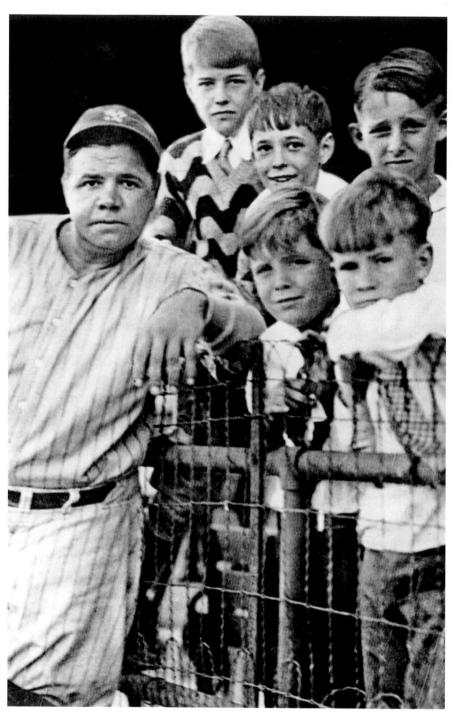

In 1933, Babe Ruth and the Yankees came to Rickwood Field. Babe Ruth seems to have visited almost every town that could boast of having a minor-league team. People may be losing sight of just how popular he was during his era. It seems Babe always had time for the kids and a photo opportunity. (Courtesy of Sam Burr.)

THE ROARING TWENTIES AND THE DEPRESSION YEARS

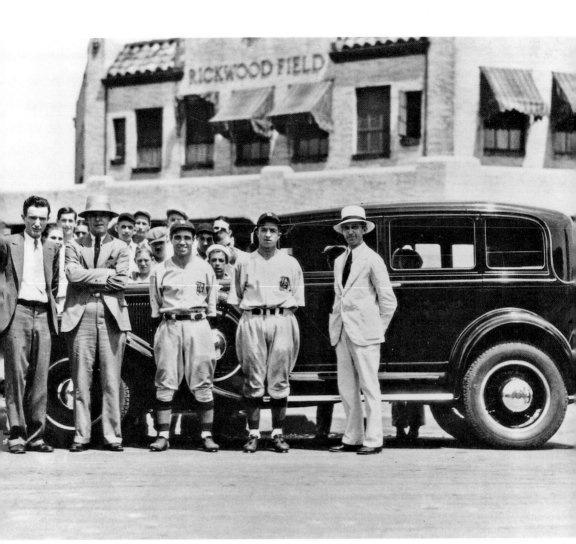

Local favorite Billy Bancroft (center) and Shine Cortozza (second from right) examine the new Studebaker automobile with the local dealers. The gentleman second from the left with arms folded is Johnny Evers, a Hall of Fame second baseman and part of the famous double-play combination of Tinker to Evers to Chance made famous by the poem "Baseball's Sad Lexicon" by Franklin Pierce Adams. At this time, Evers was a scout for the Boston Braves. (Courtesy of Chuck Stewart and Mrs. Billy Bancroft.)

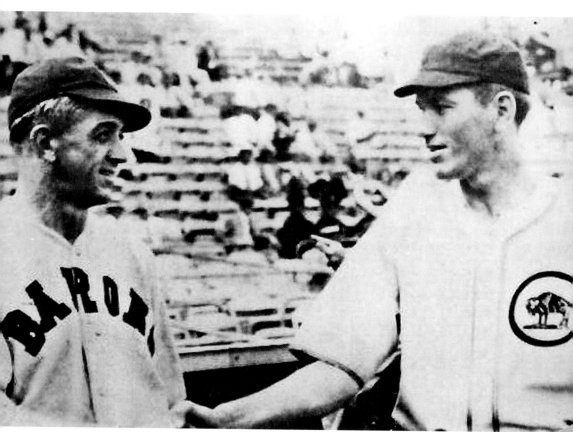

Long before Dizzy Dean made headlines with the St. Louis Cardinals, he was displaying his unique way with words in the minor leagues. In 1931, Dizzy's statements to the Houston press concerning his upcoming start against the Birmingham Barons in the Dixie Series fueled a firestorm when reprinted in the local newspaper. Local Birmingham fans packed the park to see this brash, young 22-year-old pitcher who was famous for saying, "It ain't braggin' if it is true." But Ray Caldwell, the 43-year-old, over-the-hill, alcoholic pitcher for Birmingham had other ideas about who would win the big game. Caldwell out-dueled Dean 1-0 in the first game of the Dixie Series, and Birmingham went on to win the series. Caldwell last pitched in the major leagues in 1921. The 1931 season would be his last good year, winning 19 games for the Barons. The next two years, he would only win three games and be out of baseball. Caldwell went out in a blaze of glory and a reminder of what could have been had he been able to harness his demons. (Courtesy of Houston Sports Museum.)

Eddie Wells was one of the few major-league players to have played on teams with both Ty Cobb and Babe Ruth. He played five seasons with Detroit and four seasons with New York. The time between Detroit and New York was his great year with the Barons, going 25-7 with a 2.78 ERA, which earned him his chance with New York. After his playing career, Wells settled in Montgomery, Alabama, and was a successful businessman. (Courtesy of Mickey Newsome.)

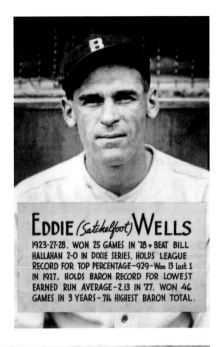

EDDIE (Satchelfoot) WELLS
1923-27-28. WON 25 GAMES IN '28 + BEAT BILL HALLAHAN 2-0 IN DIXIE SERIES. HOLDS LEAGUE RECORD FOR TOP PERCENTAGE-929-Won 13 lost 1 IN 1927. HOLDS BARON RECORD FOR LOWEST EARNED RUN AVERAGE-2.13 IN '27. WON 46 GAMES IN 3 YEARS-7th HIGHEST BARON TOTAL.

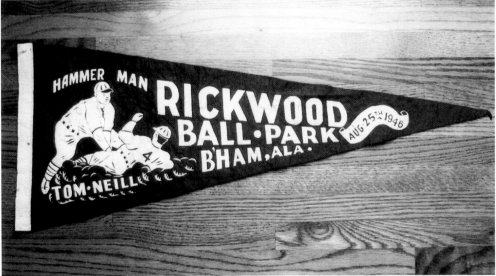

This Birmingham Barons pennant from 1946 raised a series of questions that required some research. Who was Tom Neill and why did he deserve a pennant? August 26, 1946, turned out to be Tom Neill Day at the Barons game. Tom was a local boy born in Hartselle, Alabama, and 1946 was his only year with the Barons. Tom was battling Hillis Layne, third baseman for the Chattanooga Lookouts (their opponents this day), for the batting title. At the end of the day, Layne was batting .381 and Ton Neill .380. Fans took up a collection of over $1,000 for Tom that day. Neill would go on to win the batting title with an average of .374 to Layne's .369. Tom would play baseball for 17 years, with only a few games with the Boston Braves in 1946 and 1947. For Tom and his family, August 26, 1946, was a day long remembered. (Courtesy of Mickey Newsome.)

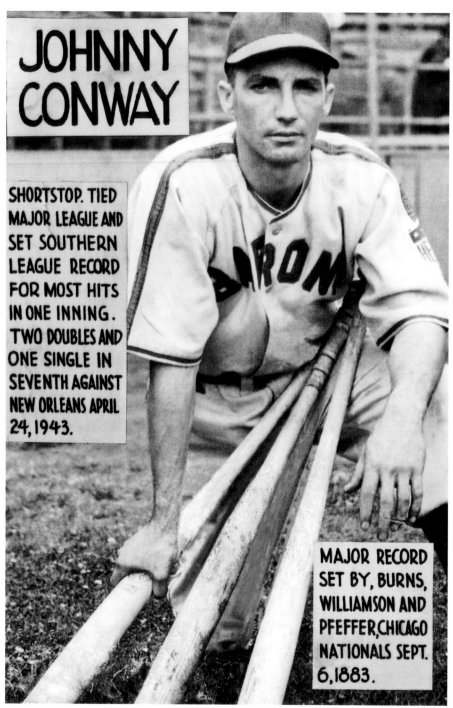

JOHNNY CONWAY

SHORTSTOP. TIED MAJOR LEAGUE AND SET SOUTHERN LEAGUE RECORD FOR MOST HITS IN ONE INNING. TWO DOUBLES AND ONE SINGLE IN SEVENTH AGAINST NEW ORLEANS APRIL 24, 1943.

MAJOR RECORD SET BY, BURNS, WILLIAMSON AND PFEFFER, CHICAGO NATIONALS SEPT. 6, 1883.

These types of pictures with a built-in caption were original photographs that were once displayed at Rickwood Field on the "Wall of Fame." After the Barons left, these pictures were dispersed among several people. This photograph of Johnny Conway tells an interesting story of his getting three hits in one inning in 1943. (Courtesy of Mickey Newsome.)

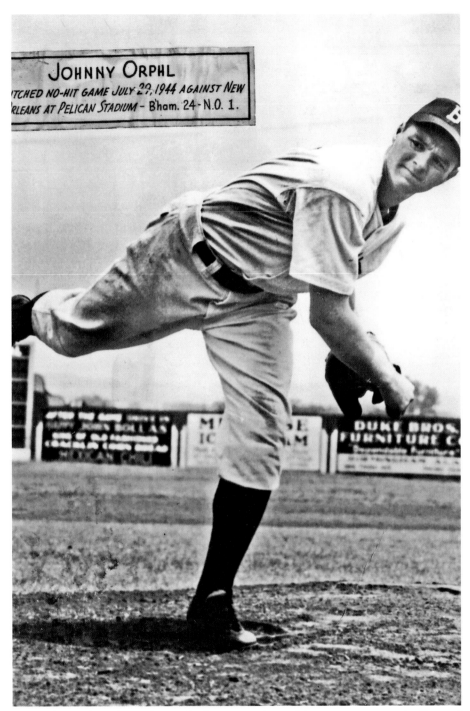

JOHNNY ORPHL
PITCHED NO-HIT GAME JULY 29, 1944 AGAINST NEW
ORLEANS AT PELICAN STADIUM - B'ham. 24 - N.O. 1.

Only 15 no-hitters have been thrown by Barons pitchers. Taking into account the Barons have played over 12,000 games, that makes Johnny Orphl's no-hitter an impressive feat. Orphl's no-hitter in 1944 was especially hard on the New Orleans Pelicans because the Barons scored 24 runs in the game. (Courtesy of Mickey Newsome.)

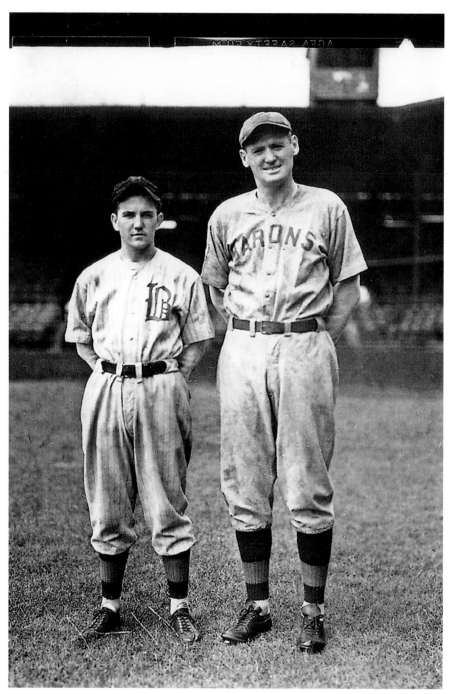

This gag photograph of Clarence "Red" Phillips and Ernest McDermott reveals that someone had a sense of humor. Phillips was a 6-foot, 4-inch pitcher who only appeared in two games for the Barons in 1939. McDermott actually never played for the Barons, but the 5-foot, 8-inch shortstop tried out for the 1939 Barons, only lasting long enough to get this picture taken. (Courtesy of Chuck Stewart.)

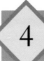

THE BIRMINGHAM
BLACK BARONS

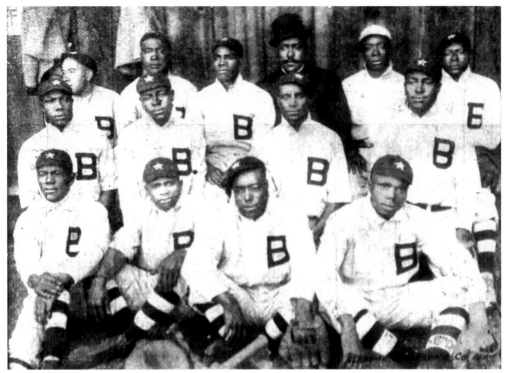

In 1904, C. I. Taylor came to Birmingham and formed the Birmingham Giants. They played at West End Park just as the Barons did. Advertisements for Giant games stated, "Returns from Southern League games will be announced at the park." Rube Foster came to Birmingham in 1908 on a barnstorming tour. He developed a relationship with C. I. that would lead to C. I. taking the Giants north on a tour the next year. Taylor then relocated his team to Indiana the following year. He is best remembered as the manager of the Indianapolis ABC's team. Along with C. I., his three brothers also played for the Giants at different times. Ben, "Candy" Jim, and John Taylor would all make their mark in the early days of Negro League baseball. In the 1930s, when Birmingham was back to being an independent team, they returned to the name Black Giants. In 1960, when a dispute arose over the rights to the name Black Barons, the new owners were ready to use the name Giants. (Courtesy of *Age Herald*.)

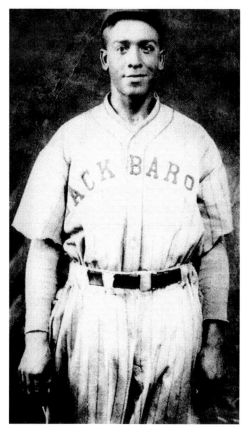

"Candy" Jim Taylor had been a part of the original Birmingham Giants of 1904 along with his brothers. He returned in 1940 to manage the Black Barons. The great job he did in Birmingham led to his getting the manager's job with the Homestead Grays. Then for the next two years, Birmingham met Homestead for the Negro League World Series, with Homestead winning both. (Courtesy of Phil Dixon and Patrick Hannigan.)

The earliest known photograph of a Black Baron is this 1922 shot of Saul Davis. Davis was born in Louisiana in 1901. He began his baseball career in the Arkansas Negro League. By the early 1920s, he was playing shortstop for the Birmingham Black Barons. Davis was a slap hitter who tried to hit singles and doubles. He used a bottle bat, the same model used by major-league player Heinie Groh. Saul Davis's playing career ranged from 1917 to 1952. (Courtesy of National Baseball Hall of Fame Library.)

THE BIRMINGHAM BLACK BARONS

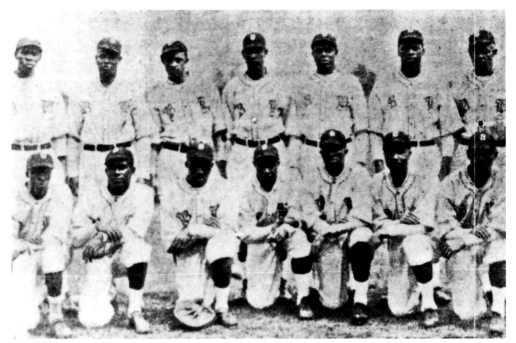

This 1928 team shot is the earliest known photograph of the Birmingham Black Barons. It is said that Satchel Paige is third from the left in the back row. (Courtesy of Friends of Rickwood.)

This 1940s team picture of the Black Barons has no identifications as to the year or players' names. Lloyd "Pepper" Bassett is the player standing on the far left end. Bassett played for the Barons from 1944 to 1952. Notice the uniform numbers for the players are on the front of their pants near their left pocket. (Courtesy of Chuck Stewart.)

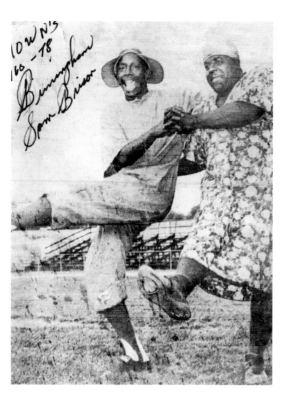

Sam Brison was one of the main stars of the Indianapolis Clowns for 16 years. He is known around town as "Birmingham Sam." Some may remember him for his part in the 1976 movie *Bingo Long Traveling All-Stars and Motor Kings*, starring James Earl Jones and Billy Dee Williams. Brison played the team's shortstop, Louis Keystone. (Author's collection.)

This is a poster from a 1940s game between the Birmingham Black Barons and the Homestead Grays. The Black Baron players listed include Piper Davis, Ed Steel, Artie Wilson, Winfield Welch, and Alvin Gipson. The Grays were managed by an old Birmingham Giant, Jim Taylor, and featured Josh Gibson and James "Cool Papa" Bell. (Courtesy of Craig Davidson.)

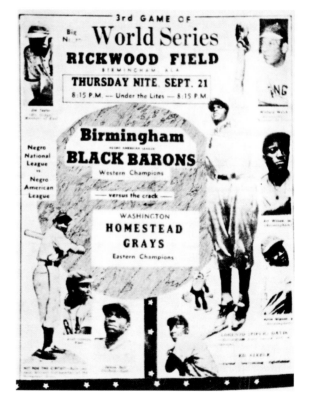

THE BIRMINGHAM BLACK BARONS

Ted "Double Duty" Radcliffe, also from Mobile, Alabama, played for just about every Negro League team; when he retired, he had played for over 30 of them. With his moving so much from team to team, it is lucky to have a picture of Ted with the Black Barons, who he played for from 1943 to 1946. He became one of the true ambassadors of the game of baseball. He was to be a guest at the February 26, 2006, game at Rickwood shown by ESPN that paid tribute to Negro League baseball, but unfortunately he passed away in 2005. (Courtesy of National Baseball Hall of Fame Library.)

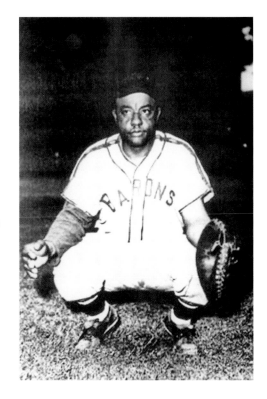

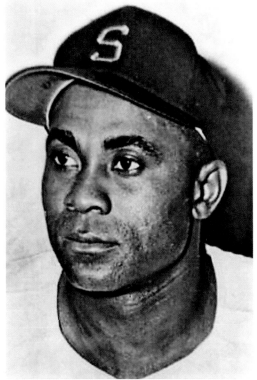

Bill Powell was a pitcher for the Black Barons from 1946 to 1950 and in 1952. He was the winning pitcher for the 1948 East-West All-Star Game. He won 20 games each year from 1948 to 1950. Powell also contributed to the team with a .286 batting average. (Author's collection.)

Artie Wilson played for the Black Barons from 1942 to 1948. Wilson was the last professional baseball player to bat over .400 in 1948. His .402 average got the attention of the New York Yankees, who signed him to a contract in 1949. (Courtesy of National Baseball Hall of Fame Library.)

There is no doubt that segregation ruled the day in Birmingham and across the South, but there seems to have been a cordial working arrangement between the Barons and the Black Barons. This advertisement in a Birmingham Barons program encourages white fans to attend the Black Barons games when the Barons were on the road. (Author's collection.)

Goings On At Rickwood Field

PRICES		GAME TIME
Men............$1.00 Ladies.........$.70		NITE GAMES
Ladies Nite25		Single 7:30 P.M. Double 6:15 P.M.
Students50		Sunday 2:00 P.M.
Child (under 12)25		
Box Seats30		NITE DOUBLEHEADERS
White Bleachers70		First Game.......................7 innings
Tax Included In Above		Second Game...................9 innings

When Barons Are Away Come Out and See The Black Barons
MEMBER OF NEGRO AMERICAN LEAGUE

BLACK BARONS SCHEDULE – FIRST QUARTER OF 1947

APRIL 16—BLACK BARONS vs. HOMESTEAD GREYS
APRIL 17—BLACK BARONS vs. HOMESTEAD GREYS
APRIL 25—CINCINNATI CLOWNS vs. KANSAS CITY MONARKS
*APRIL 27—BLACK BARONS vs. ASHVILLE BLUES
APRIL 30—BLACK BARONS vs. PHILADELPHIA STARS
*MAY 11—BLACK BARONS vs. KANSAS CITY MONARKS
MAY 14—BLACK BARONS vs. KANSAS CITY MONARKS
* Sunday

Lloyd "Pepper" Bassett was one of the great Negro League catchers. He was a fan favorite in Birmingham. He played eight years for the Black Barons from 1944 to 1952. This was certainly uncommon in a time when players changed clubs almost yearly in search of a better salary. Bassett, like many players, knew how to entertain the fans. He would catch while sitting in a rocking chair and make accurate throws to second base. (Courtesy of National Baseball Hall of Fame Library.)

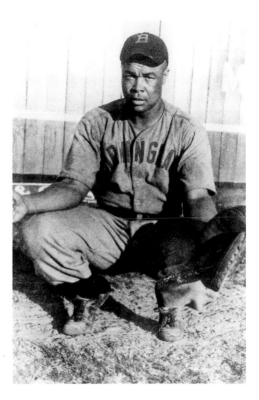

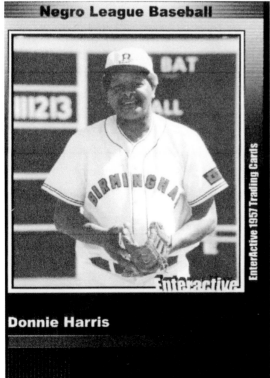

Donnie Harris played for the 1957 Birmingham Black Barons and made the East-West All-Star team in 1957. He went on to play in the Pittsburgh Pirates and Kansas City organizations. (Author's collection.)

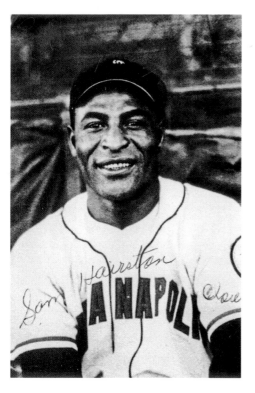

Sam Hairston's legacy in baseball is far reaching. He was the first black player on the Chicago White Sox team. He was father to pro baseball players Jerry and John and grandfather to Jerry Jr. and Scott, who are playing in the majors now. (Courtesy of Birmingham Barons.)

Lyman Bostock Sr. began his baseball career in 1938. In 1940, he joined the Black Barons. He made the All-Star team in 1941. Lyman Bostock was considered one of the elite first basemen of the Negro Leagues. He dreamed, along with many black players, of playing in the majors. Lyman never saw that dream come true, but he did see his son Lyman Jr. play four years in the major leagues before Lyman Jr. was tragically killed in 1978. Lyman Sr. was known in Birmingham among baseball fans for his carved homemade bats. (Author's collection.)

Dan Bankhead was born in Empire, Alabama. He was one of five brothers who played in the Negro Leagues and the only brother to play in the major leagues. In August 1947, Dan became the first black pitcher in the major leagues, playing for the Brooklyn Dodgers. Unbelievably, he hit a home run in his first major-league game. All four of Dan's brothers played for the Black Barons at different times. (Courtesy of Friends of Rickwood.)

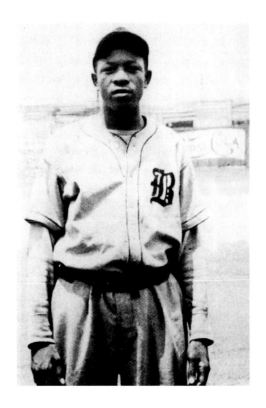

Bob's Savoy Cafe

FOR THE FINEST IN
SEA FOODS - STEAKS - CHOPS
REGULAR DINNERS

DRINKS? COURTEOUS SERVICE
ALWAYS PREVAILS

RADIO STATION
W E D R

1220 Kilocycles
1000 Watts
The South's FIRST
ALL-NEGRO Station

10ᶜ Official Score Card 10ᶜ

BIRMINGHAM
BLACK BARONS

● ***You Bet We're Crowing***
About Our Barons!
THEY WERE NOT LATE IN '49
THEY'LL BE ON TIME IN '50

TOM HAYES, Owner Vic Harris, Mgr.

AFTER THE GAME
Leslie's Owls Club

Artifacts from Negro League baseball are truly rare. This scorecard of the Birmingham Black Barons was not much different than a Barons scorecard. It contained the schedule of upcoming games, a picture of the team, a score page, and advertisements from local merchants. (Author's collection.)

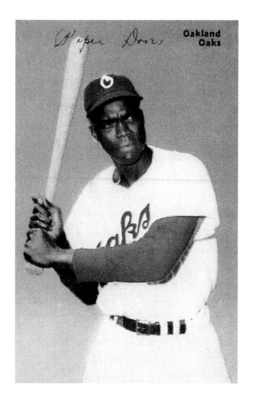

A multitalented athlete, Piper Davis not only played professional baseball but also basketball for the Harlem Globetrotters. Piper was the manager and a player of the 1948 Black Baron championship team, which included a teenage player named Willie Mays. (Courtesy of Chuck Stewart.)

Bill Greason played for the 1948 championship Black Barons. He later became the first African American player with the Tulsa team in the Texas League. He also signed with the St. Louis Cardinals, enjoying a brief period with the Cardinals in 1954. After baseball, he became a Baptist minister. (Author's collection.)

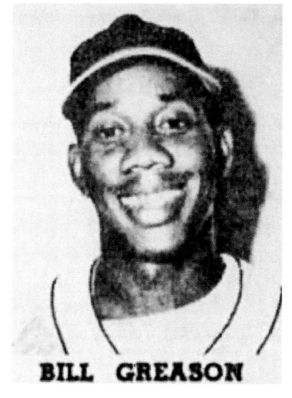

BILL GREASON

Frank Evans played for the Memphis Red Sox and the Birmingham Black Barons. He was a teammate of Willie Mays on the Chattanooga Choo-Choos. Evans was the last manager of the Black Barons. After the demise of the Negro League, Frank was a scout and coach in the Montreal Expos and Kansas City Royals organizations. Frank was responsible for signing many talented players who went on to have major-league careers. (Courtesy of Frank Evans.)

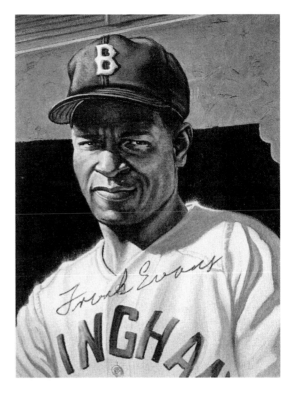

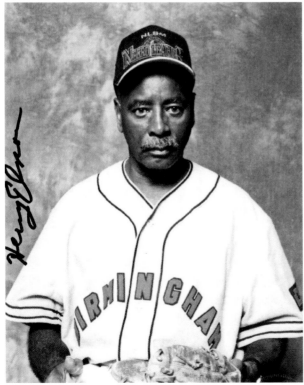

Henry Elmore was an infielder for the Birmingham Black Barons in the late 1950s. He also played for the Philadelphia Stars. His great-uncle Jim West played for the Cleveland Buckeyes. The highlight of his career was playing with Satchel Paige and Goose Tatum. (Author's collection.)

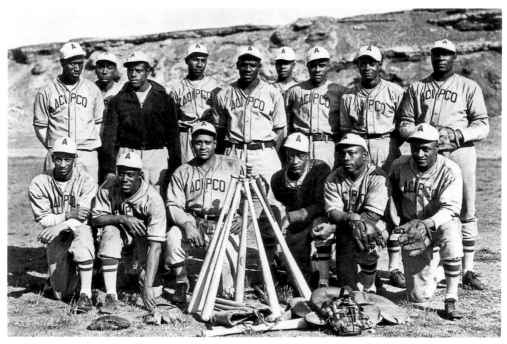

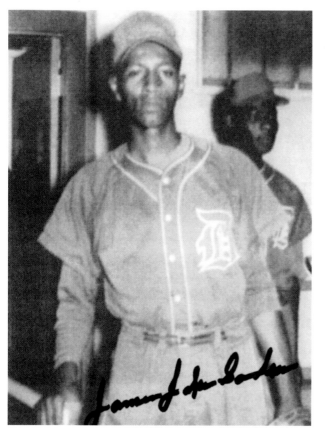

The backbone of Birmingham's strong baseball presence was the industrial league of the local steel mills. The mill teams were an especially fertile ground for the Black Barons to recruit talented players. (Courtesy of Friends of Rickwood.)

Jake Sanders played three years for the Kansas City Monarchs, posting a batting average of .325. He played in the East-West All-Star game. Sanders has served as president of the Alabama Negro League Players Association. (Courtesy of Jake Sanders.)

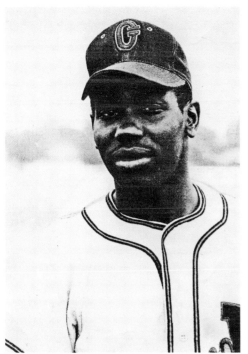

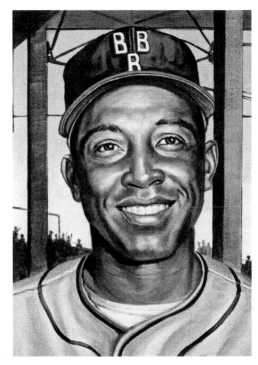

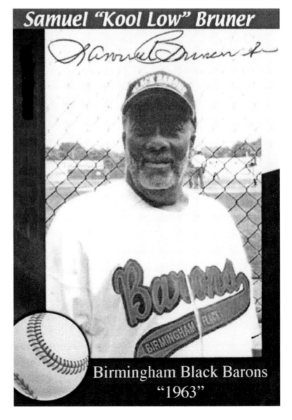

Samuel "Kool Low" Bruner

Birmingham Black Barons
"1963"

Jehosie Heard (above right) was a left-handed pitcher for several Negro League teams, including the Birmingham Black Barons and the Memphis Red Sox. Jehosie was the first black player for the Baltimore Orioles in 1954. He was 34 years old when he made his major-league debut. Roger "Stud" Brown (above left) played shortstop and third base for the 1958–1960 Birmingham Black Barons. He also played one year with the Kansas City Monarchs. Brown played baseball during his military career while based in Germany. He has recently returned home to Birmingham to live. Samuel "Kool Low" Bruner (right) played for the Birmingham Black Barons. He was an outfielder with a .227 batting average. His most cherished memory is hitting a single off Hall of Fame pitcher Satchel Paige. (Above left, author's collection; above right, courtesy of Roger Brown; right, courtesy of Samuel Bruner.)

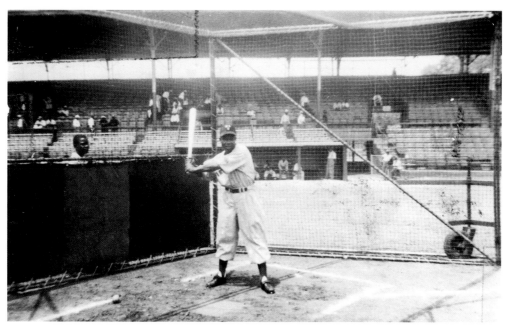

The starting center fielder for the 1948 Birmingham Barons was Norman Robinson. A very young Willie Mays joined the team just as an extra outfielder. Opportunity came around for Mays when Robinson broke his leg in June, giving Mays his chance. Slowed by the injured leg, Robinson moved to left field when he returned to the lineup. Norman's brother Frazer was Satchel Paige's favorite catcher. (Author's collection.)

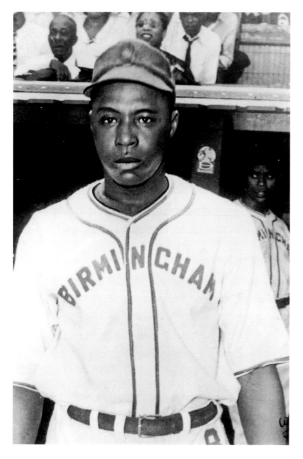

Herman Bell was a catcher for the Birmingham Black Barons from 1943 to 1950. He was a good catcher with an erratic throwing arm. Bell batted .277 in his best year for the Black Barons. Herman Bell mainly served as the backup catcher for Pepper Bassett. (Courtesy of Friends of Rickwood.)

THE BIRMINGHAM BLACK BARONS

Willie C. Young was born without a right hand, but this did not stop him from competing on the baseball field. He played for the 1945 Black Barons and the 1949–1950 Nashville Black Vols. Here Willie is pictured in his Stockham Valve uniform of the Birmingham Industrial Leagues. Before there was Jim Abbott, there was Willie C. Young. (Author's collection.)

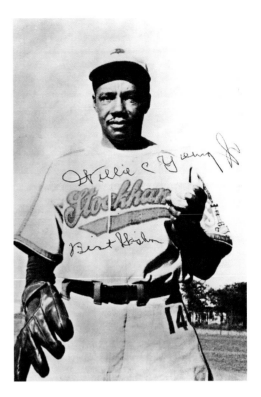

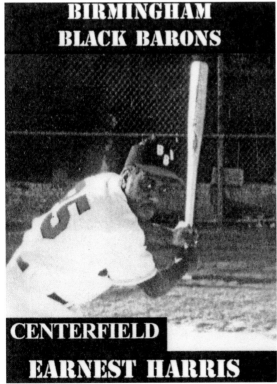

Earnest Harris, born in Birmingham, Alabama, played center field for the 1959 Black Barons and manager Piper Davis. Harris hit an inside-the-park home run in the East-West All-Star game in 1959 in Chicago. (Courtesy of Earnest Harris.)

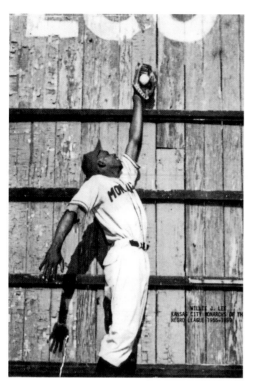

Willie Lee was born in Birmingham, Alabama. He began his baseball career at age 14. Playing for local teams prepared him to join the Negro League teams. Willie played for the Birmingham Black Barons and the Kansas City Monarchs from 1955 to 1958. He was selected for the 1956 East-West All-Star team. After his time in the Negro Leagues, Willie played in the Detroit and Minnesota organizations. (Courtesy of Willie Lee.)

Frank Marsh, from Mobile, Alabama, played for the Black Barons in 1954. He also played for the Kansas City Monarchs and the Detroit Stars. He played in three East-West All-Star games in 1954, 1955, and 1956. (Courtesy of Frank Marsh.)

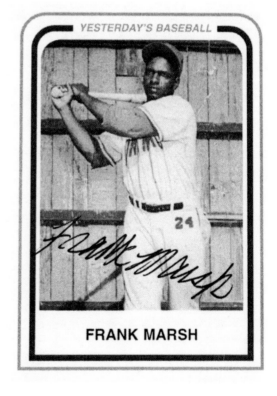

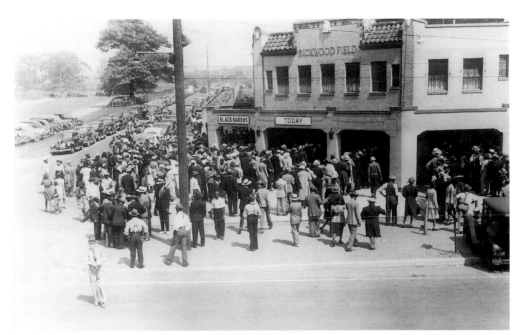

Fans wait in line to see the Black Barons play. Notice the sign on the front entrance that says Black Barons. These signs changed to let fans know which Barons were playing. The attire of the fans shows that going to a Black Barons game was special. Many went to church and then attended the game in their Sunday best. (Courtesy of Friends of Rickwood.)

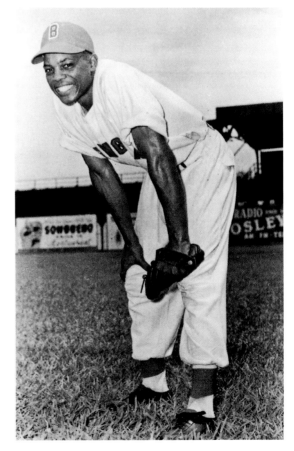

No state has produced the array of major-league talent that compares with Alabama. When one takes into consideration the populations of states like Ohio and California, it becomes even more remarkable. At the top of this distinguished list of Alabama talent is Willie Howard Mays. As a teenager still in high school, he began playing with the Chattanooga Choo-Choos and then the Birmingham Black Barons. In 1951, Willie reached the major leagues, playing for the New York Giants. (Courtesy of Memphis Public Library.)

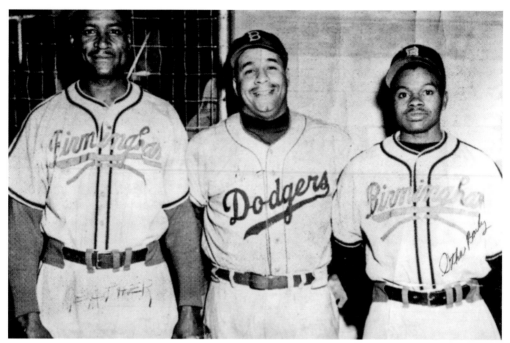

Birmingham Black Baron Otha Bailey (far right) and an unidentified player visit with Brooklyn Dodger catcher Roy Campanella (center). Bailey was also a catcher. (Courtesy of Carlile's BBQ.)

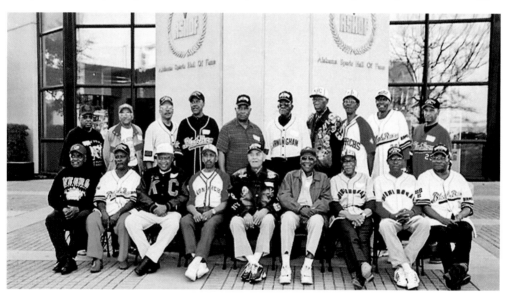

The Birmingham area is blessed with the largest contingency of former Negro League baseball players in the nation. This may be due in part to so many of the players having gotten their start in the industrial leagues and choosing to stay in Birmingham because it was home. The players formed their own organization, the Alabama Negro League Association. Their accomplishments include scholarships, baseball clinics, and relating their history in schools and universities across the South. (Courtesy of Alabama Negro League Players Association.)

5

THE GOLDEN AGE

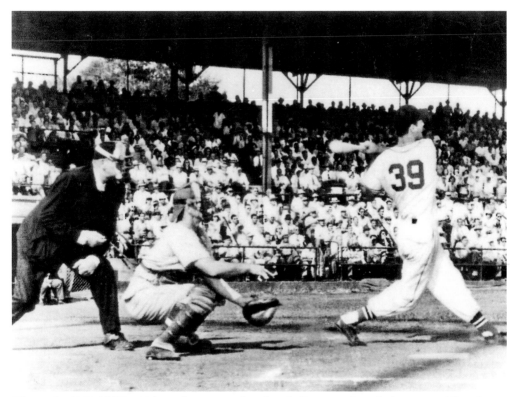

The end of World War II brought a revival to baseball across the whole nation. The players were back, and the returning servicemen were hungry to see their game. For the first time in many years, the Barons had local ownership since Gus Jebeles had purchased the team. Jebeles was determined to bring the Barons back to the golden years he remembered as a boy. He hired Eddie Glennon to run the ball club. Glennon knew how to promote the team and keep the fans coming through the turnstiles. He made several key improvements to the park, including bringing in the left-field fence to promote more home runs, remodeling the ladies' restrooms, and building the Dugout Restaurant. The final piece of the puzzle was signing an agreement to be the Double-A farm team for the Boston Red Sox. The year 1948 was a banner one for the Barons. The franchise set an all-time attendance record of 445,926 fans. Walt Dropo powered the Barons to a second-place finish in the league, and the Barons went on to win the Dixie Series over the Houston Buffaloes. (Courtesy of Friends of Rickwood.)

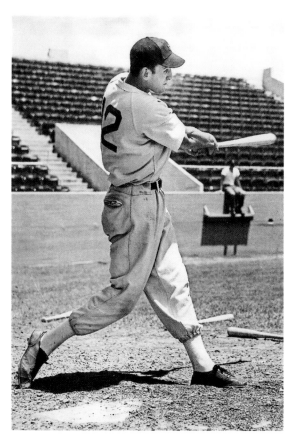

One of the most often told stories about Norm Zauchin is the way he met his wife, Janet, at Rickwood. Norm was playing first base one game when a foul ball was hit toward the first-base stands. Going after the ball, Norm fell over the railing onto a young woman's lap. About a year later, that young woman became Mrs. Norm Zauchin. (Courtesy of Birmingham Barons.)

George "Firpo" Burpo stands near the top of the list of wild pitchers who could not find home plate. Teams seem to be more patient if the pitcher is a lefty like Burpo. In 1942, Burpo walked 127 batters, second only to Del Lundgien's 136 in 1924 on the all-time Barons list. (Courtesy of Mickey Newsome.)

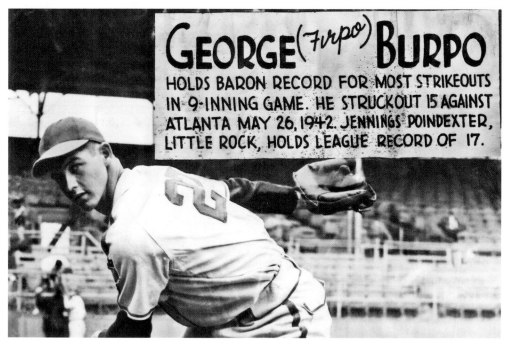

GEORGE (Firpo) BURPO HOLDS BARON RECORD FOR MOST STRIKEOUTS IN 9-INNING GAME. HE STRUCKOUT 15 AGAINST ATLANTA MAY 26, 1942. JENNINGS POINDEXTER, LITTLE ROCK, HOLDS LEAGUE RECORD OF 17.

The 1948 Dixie Series championship team was one that specially blended youth and maturity, players who worked together as a team. Only Walt Dropo went on to have a significant career in the majors. George Wilson put up good numbers in the minors but never caught on in the big leagues. Bill Dickey's brother George was on the team as a backup catcher, and that would be his last year in professional baseball. Harry Dorish pitched for 10 years in the majors, mostly relief appearances. Tommy O'Brien's outstanding 1948 season would only get him a brief trial with the Washington Senators. This championship team did not produce much fruit for the parent club, the Boston Red Sox. (Courtesy of Friends of Rickwood.)

Jim Piersall had an outstanding season at Birmingham in 1951. It got him a spot on the Boston Red Sox team for the next season. The Boston manager decided during spring training to move Piersall from center field to shortstop. This, along with his mental condition, led to problems on and off the field. Piersall was sent back to Birmingham to hopefully work through his issues. Here is Piersall (left) arriving at Rickwood Field to the glad reception of his manager Red Mathis (right) and the crowd. Unfortunately he only lasted a couple of weeks and was returned to Boston to seek medical help for his mental condition. (Courtesy of Friends of Rickwood.)

Gus Jebeles had been a lifelong Barons fan. In 1944, he purchased the Barons from the Cincinnati National League team. When World War II ended, all of baseball embarked on a golden age. Jebeles hired a quality general manager, Eddie Glenn, and signed a working agreement to be the Boston Red Sox minor-league affiliate. With so many servicemen home from the war, attendance at the ball games grew rapidly. Gus put all the pieces together for Birmingham to enjoy the revel of baseball before air-conditioning and television took their toll. (Author's collection.)

G. J. JEBELES
President and Owner of the Baro

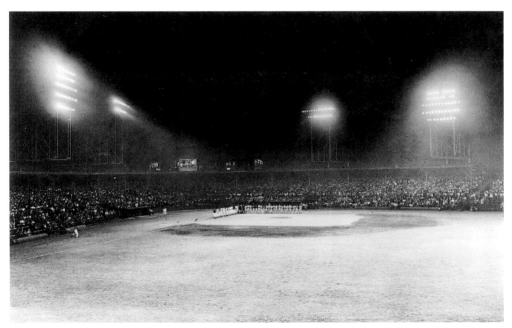

This is a rare photograph of a night game at Rickwood. It was taken from the top of the "Negro" bleachers beyond right field. The capacity crowd and the players who were lined up on the baselines would lead one to think it was a special game like opening day, a playoff, or an all-star game. (Courtesy of Friends of Rickwood.)

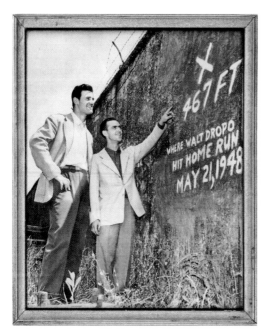

In a game against the Mobile Bears on May 21, 1948, the Barons little second baseman Eddie Lyons hit a home run, only to be outdone by heavy-hitting first baseman Walt Dropo. Dropo's home run traveled over the left-field scoreboard to the right of the scoreboard clock. In recent years, a plaque was placed where the ball hit the fence. The plaque replaced the now faded-out "X" that was painted on the wall the day after Dropo hit his mammoth shot. (Author's collection.)

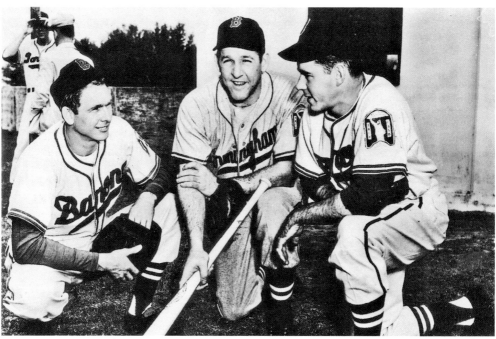

Home-run power for the 1950 Barons was provided by this trio of sluggers. Norm Zauchin (center), the first baseman, provided 35 homers, while Fred Hatfield (left) contributed 27 homers. Youthful phenom Karl Olson (right) added 23 round-trippers. Charlie Maxwell, not pictured here, hit 25 home runs. Notice the shoulder patch worn by the players featuring a picture of the Vulcan, the symbol of Birmingham and its ties to the steel industries. The patch commemorates the 50th anniversary of the Southern Association. (Courtesy of Birmingham Barons.)

　　　　　　　　　　　　　　　　　　THE GOLDEN AGE

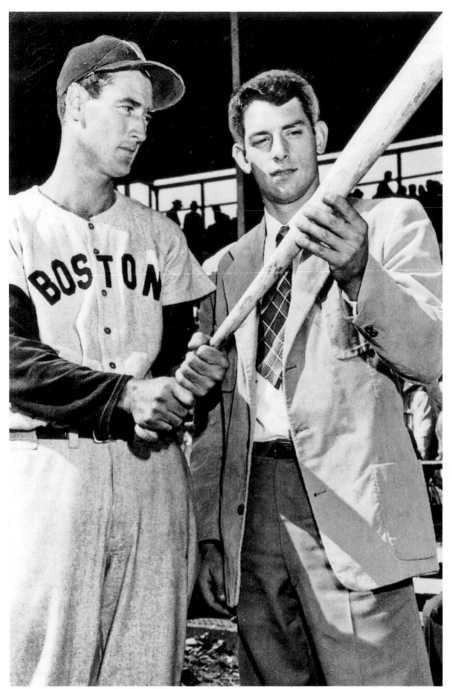

During the 1947–1952 era of Barons baseball, when the Barons were affiliated with the Boston Red Sox, local fans were treated to the experience of seeing probably the best hitter of all time, Ted Williams. Williams left fans in awe one year by hitting a home run over the right-field stands. In this photograph of Ted (left) at Rickwood, with an unidentified man, he discusses the art of hitting the baseball. (Courtesy of Ginny Newman.)

Danny Ryan was a fixture for the Barons in the 1950s. He began as a catching prospect in the Red Sox organization, and even when the Red Sox parted ways with Birmingham, Danny stayed with the Barons. In 1955, he split time between managing the Greenwood Bucks in the Cotton State League and playing for the Little Rock Travelers. Danny returned to Birmingham in 1956 and retired after the 1959 season. (Author's collection.)

Built in the early 1950s, the Dugout Restaurant was to the right of the front entrance. It was a very popular hangout with a screened-in eating area. It was for some time the only place in Birmingham one could buy a beer on Sunday. Today that restaurant serves as the conference room for Rickwood Field. (Courtesy of Friends of Rickwood.)

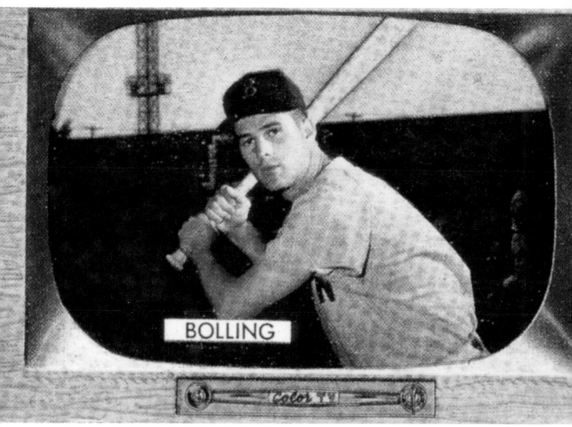

A local sportswriter pegged Milt Bolling as the next Pie Traynor. Pie Traynor had been the shortstop for the Barons in 1921 and went on to become a Hall of Fame third baseman for Pittsburgh. Milt never lived up to those expectations. He was a good defensive infielder and the brother of Frank Bolling. Milt and Frank's uncle Jack Bolling also played in the major leagues. The Bollings were from Mobile, Alabama. (Author's collection.)

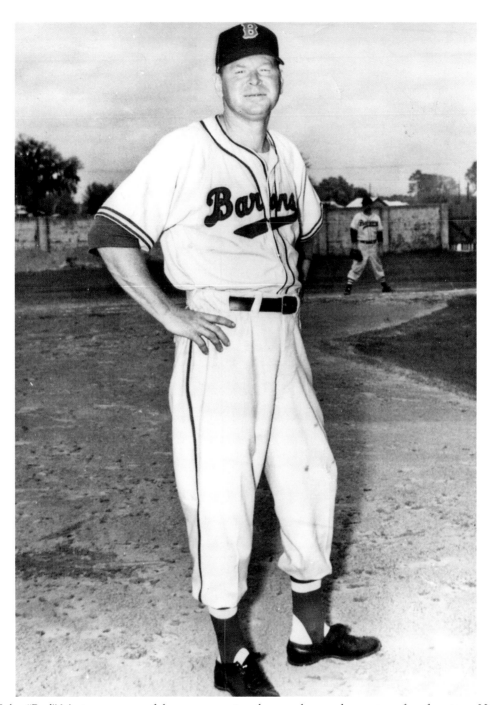

John "Red" Marion was one of those career minor-league players who are too often forgotten. He played 14 years in the minors and followed that with a 23-year managerial career that overlapped his playing career. He managed the Birmingham Barons in 1951, posting an 83-win season for a second-place finish. He was also the brother of famed Cardinal shortstop Marty Marion. (Author's collection.)

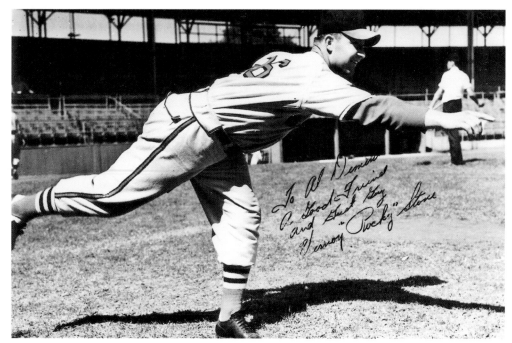

Barons pitcher Vernon "Rocky" Stone signed this photograph to team owner Al Dement. Dement was part of a trio, along with Albert Belcher and Rufus Lankey, that owned the Barons. What is interesting is that Stone's last year with Birmingham was 1947 and Al Dement did not become part owner until 1949. Dement was first and foremost a fan of the game and, as Stone wrote, "A good friend and great guy." (Courtesy of Friends of Rickwood.)

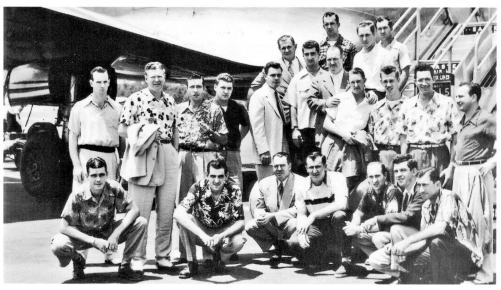

At the close of the 1951 season, the Barons flew off to Houston, Texas, to face the Buffaloes in the Dixie Series. The Barons would win the series 4-2. Unfortunately the players in this image cannot be identified other than Jim Piersall (standing third from left). (Courtesy of Bob Scranton.)

THE YANKEES

AND THE DECLINE

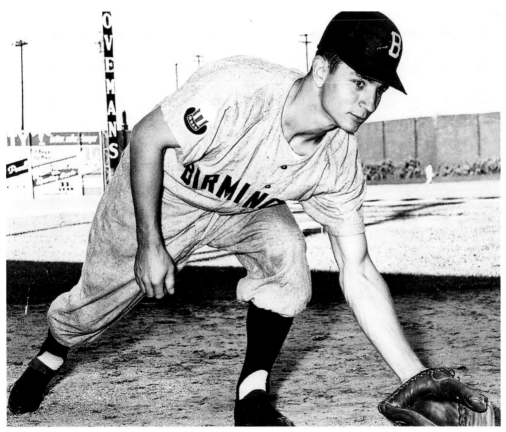

Milton Graff played for the Birmingham Barons during the New York Yankees era in 1956. Baron uniforms during that time reflected the team's ties to the Yankees. Graff's uniform shows the familiar Yankee top hat on his right sleeve. The other sleeve patches during the Yankee era in Birmingham included the letters *NY* with a rebel flag on the opposite sleeve. In 1957, the Yankees traded Graff and Billy Hunter to the Kansas City Athletics for Ralph Terry. Graff, like a lot of players on the Barons roster during the Yankee era, became part of the player merry-go-round between New York and Kansas City. Early on, the Yankee farm system was loaded with talented players. By the end of the 1950s, the talent was gone and was not being replaced by the new crop of young players. (Author's collection.)

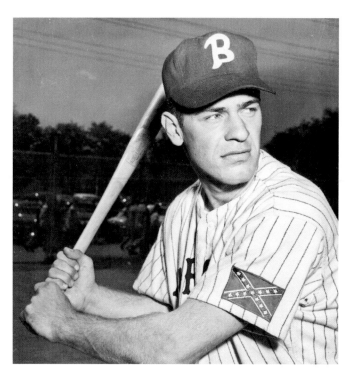

Gus Triandos was a good-hitting first baseman for the 1953 Barons. The Yankee farm system was loaded with talented players, enabling the Yankees to make a monster trade in 1954 with the Baltimore Orioles. The Yankees got Bob Turley, future Cy Young Award winner, and Don Larsen, who would go on to pitch the only perfect game in World Series history. One of the players Baltimore got was Triandos, whom they turned into an all-star catcher. (Author's collection.)

John Blanchard was the catcher for the 1956 Barons. He was just one of the many talented major-league catchers that the Yankee farm system produced. Unfortunately John never got enough playing time with the Yankees. He was the third-string catcher behind Yogi Berra and Elston Howard. A glimpse of what could have been was John's 21-home run season in 1961 as a part-time player for the Yankees. (Author's collection.)

Barons fans from 1953 to 1956 were treated to several exhibition games with the New York Yankees. The Baron teams of that era not only provided many players to stock the Yankee rosters but also had the players to trade to get Bob Turley, Don Larsen, and Roger Maris. (Author's collection.)

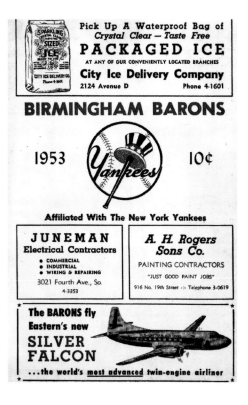

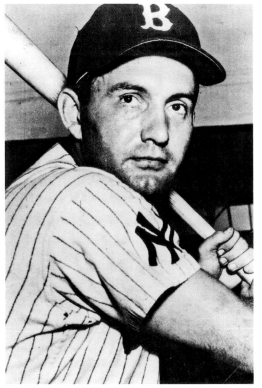

Tom Hamilton only played a few games in the majors with the Philadelphia Athletics in 1952. He had two good seasons with the Barons in 1954 and 1955, but the record he is remembered for was set on May 17, 1955, against the New Orleans Pelicans playing first base for the Barons. He did not have a single fielding chance at first base for the whole game. (Courtesy of Friends of Rickwood.)

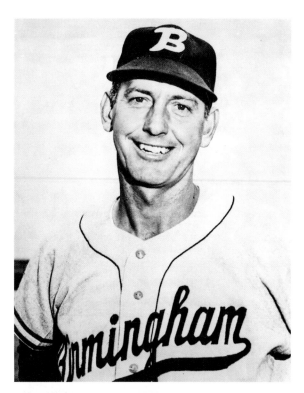

Mayo Smith was a career minor-league outfielder. In 1945, he played his only season in the majors with the Athletics. He soon found himself managing in the New York Yankees farm system. Smith managed the Birmingham Barons for two seasons in 1953 and 1954. His managerial skills caught the eye of the Philadelphia Phillies, who named him manager in 1955. Smith managed the Phillies for four years, Cincinnati for part of the 1959 season, and four years with Detroit, his best year being 1968 playing St. Louis in the World Series. (Author's collection.)

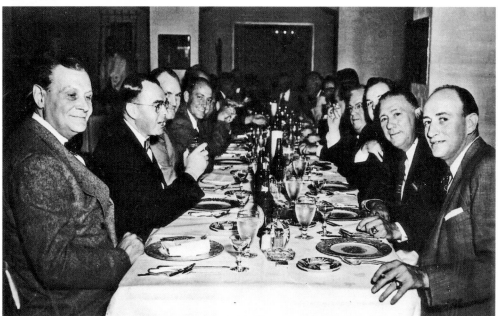

Here the brain trust of the 1954 Birmingham Barons enjoys a dinner and conversation at the baseball meetings. From front to back on the left side of the table are owners Al Belcher, Al DeMent, general manager Eddie Glennon, and manager Mayo Smith. This was the Yankee era of Barons baseball. (Courtesy of Friends of Rickwood.)

THE YANKEES AND THE DECLINE

Al Pilarcik was traded by the Yankees to Baltimore in a blockbuster move. He is remembered most as the Oriole outfielder in right field when Ted Williams hit a home run in his last at-bat in Boston in 1960. (Author's collection.)

This is an action shot of Milt Graff sliding into third base in a game on May 13, 1956, against the New Orleans Pelicans. The newspaper gave it the title "The Disappearing Baron." It looks like Milt is going to be safe. (Courtesy of Carlile's BBQ.)

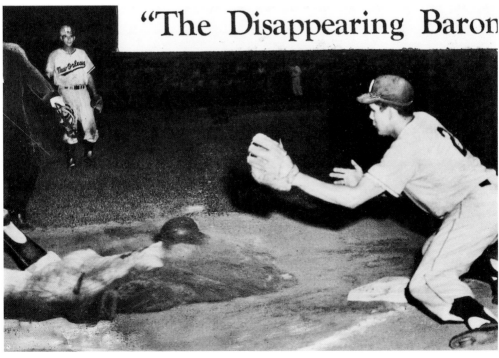

"The Disappearing Baron

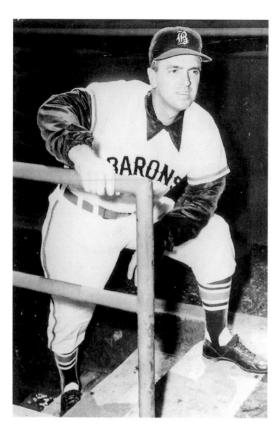

At the end of the 1957 season, Joe Engel, owner of the Chattanooga Lookouts, was slow to offer manager Cal Ermer a contract extension. Ermer got tired of waiting and contracted Eddie Glennon, the Barons' general manager. Ermer signed with the Barons and managed the team to the 1958 Southern Association championship. (Courtesy of Dan Creed.)

Sam Suplizio scores as the catcher for the New Orleans Pelicans bobbles the ball. Barons catcher Dan Ryan watches his teammate score as he prepares to bat next in this 1956 game. (Courtesy of Carlile's BBQ.)

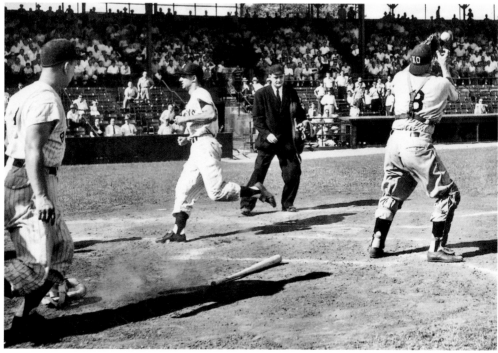

THE YANKEES AND THE DECLINE

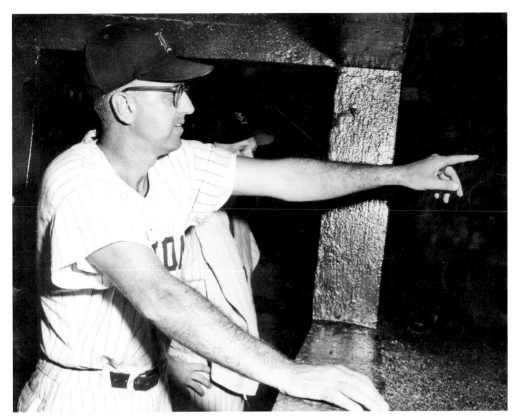

Barons manager Cal Ermer is shown here in the dugout at Rickwood Field orchestrating the moves of his team. At the age of 27, Calvin Griffith saw Ermer's potential as a manager. Cal spent most of his 60-plus-year baseball career with the Minnesota/Washington organization. (Courtesy of Dan Creed.)

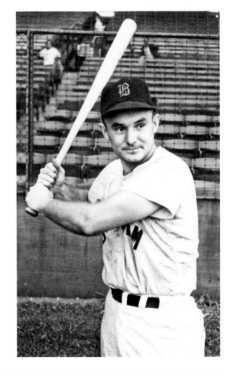

Steve Demeter was the younger brother of major-league outfielder Don Demeter of the Philadelphia Phillies. Steve played for the Barons in 1957 and 1958. He hit 31 home runs during his two seasons in Birmingham, but it only got him a "cup of coffee" in the big leagues with Detroit and Cleveland in 1959 and 1960. (Author's collection.)

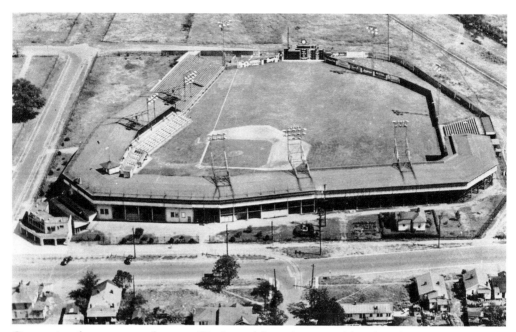

Comparing these two aerial views of Rickwood from the 1940s (above) and about 1960 (below) reveals the continuing evolution of the ballpark. The 1940s picture shows that the large tree in the parking lot is still there, the Dugout Restaurant has not been built yet, and the streetcar line is visible on Twelfth Street West curving into the neighborhood. The old scoreboard from the 1928 remodel is gone and replaced, along with a new, shorter left-field fence. Near the gazebo, there are several small huts built to house the press and scorekeeper. One can still see the advertising on the concrete wall, even though the newer inner wall in center field has been built. Also added are some box seats in front of the third-base line bleachers. (Courtesy of Friends of Rickwood.)

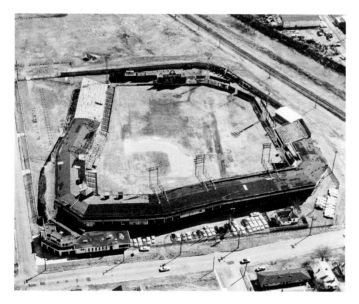

This 1960s photograph shows signs of a football game being played in the recent past. Though some like to think of Rickwood Field as never changing, in fact, like all things in life, it is constantly changing—not always for the best. (Author's collection.)

THE YANKEES AND THE DECLINE

Eddie Glennon was the Barons general manager from 1946 to 1961. Eddie grew up in Philadelphia near Shibe Park, home of the Athletics. Due to the Barons' close relationship with Connie Mack, Gus Jebeles was able to hire Glennon to be his new general manager. In spite of his ties to the Athletics, he suggested a switch to the Boston Red Sox farm system, which proved to be a good decision for the Barons. (Courtesy of Bob Scranton.)

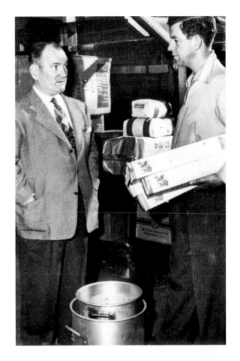

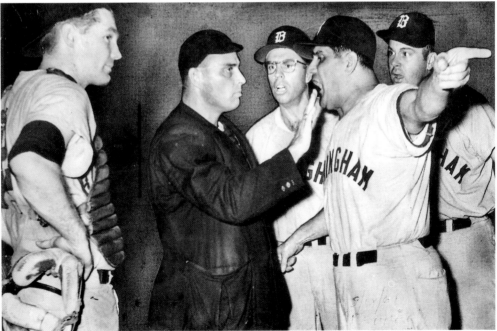

This rhubarb in a game on August 12, 1961, had the Barons' manager Frank Skaff (second from right), third baseman Herb Plews (center), and first baseman Tom Hamilton (far right) steaming mad. Catcher John Sullivan seems somewhat disgusted. Notice umpire Dougherty's hand gesture, which led someone to write "Fuehrer Daugherty" at the bottom of the picture. (Courtesy of Carlile's BBQ.)

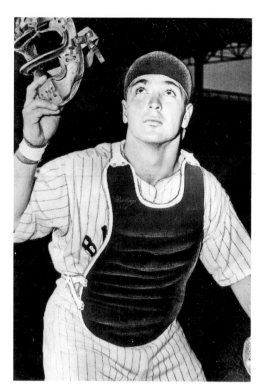

Lou Berberet was a promising catcher in the Yankee organization. He even got into a few games with the Yankees in 1954 and 1955. In 1954, Lou hit 18 home runs and scored 118 runs for the Barons. But when a player has to beat out Yogi Berra and Elston Howard to get playing time, his chances are not too good. Lou was traded to Washington in 1956, later playing for Boston and Detroit. (Courtesy of Carlile's BBQ.)

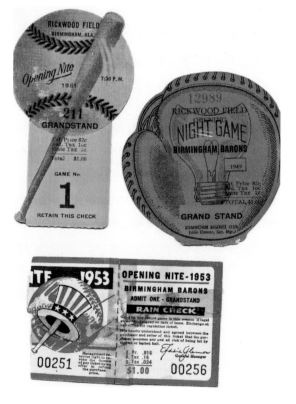

This collection of opening-day ticket stubs from the early 1950s shows great creativity. The 1953 stub reflects the Barons' connection with the New York Yankees. The opening-day ticket was made very colorful and unique, and the season schedule was printed on the back so that the fan would hold on to the stub for the whole season. (Courtesy of Barton Leaf.)

In the history of the Southern Association, no player hit four home runs in a regular-season game; several players have hit three home runs in a game. In 1955, Jim Lemon hit four homers in the All-Star game at Rickwood Field. Notice the baseball gloves left on the field, a common occurrence between innings back then. (Courtesy of Friends of Rickwood.)

The 1956 Barons were piloted by Phil Page, a journeyman pitcher who spent the last half of a 13-year career buried in the Yankee farm system. After his playing days, Phil turned to managing. The year 1956 would be the end of the New York/Birmingham relationship. John Blanchard would be the only 1956 Baron to contribute to the Yankee dynasty. Fritz Brickell was the son of former major-league player Fred Brickell. He is remembered for his 1961 baseball card in which he looked like a 12-year-old boy. A sad note about shortstop Fritz was that he tragically died of cancer before his baseball dreams were fulfilled. (Courtesy of Friends of Rickwood.)

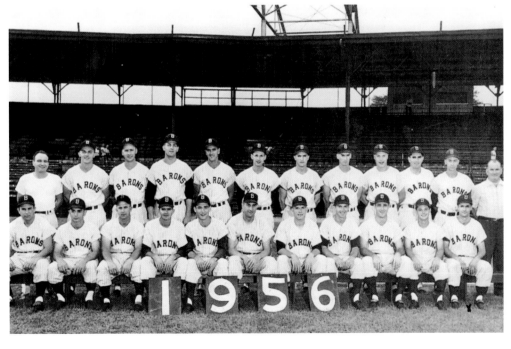

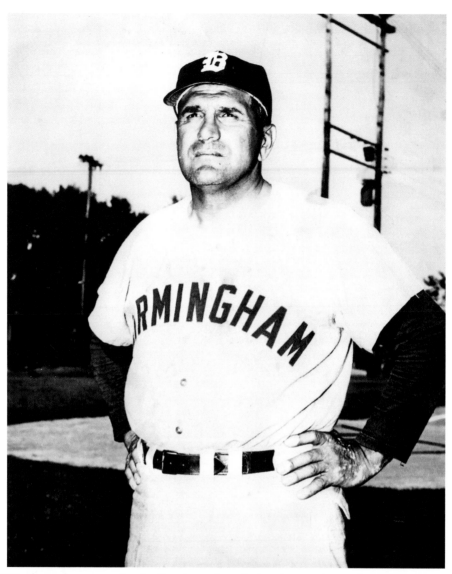

By 1961, the end was near for the Southern Association. Integration or fear of integration got most of the blame, but there were several factors that led to the collapse of the league. The glory days of the post–World War II boom had faded. Television continuously eroded the fan base. By 1960, probably all cities had three major networks broadcasting in their market. Fans were not staying away to watch major-league baseball during the week but to watch Andy Griffith or Red Skelton. Home air-conditioning coupled with television provided a one-two punch too powerful to resist. And last but not least was "urban flight;" many Birmingham families began to relocate "over the mountain." The interstate system was being built and would take years to complete. The longer drive to the ballpark made it impractical to go. Attendance had gone from 372,089 in 1950 to 112,217 in 1961. Other Southern franchises experienced even sharper declines. The owners saw no hope for the future, and at the close of the 1961 season, the league folded. Frank Skaff managed the last Barons team in 1961. (Author's collection.)

CHARLIE O. TAKES OVER

Charles O. Finley, a self-made millionaire in the insurance business, decided he wanted to buy a major-league baseball team. After one unsuccessful attempt, he purchased the Kansas City Athletics in 1960. Finley was from Birmingham and had been a batboy at Rickwood Field in his youth. Like Rick Woodward, his first desire was to be a baseball player, but when that did not materialize, owning a team would do. In 1964, the new Southern League was formed and the teams would be integrated. Finley wanted Birmingham to be in the new league and placed his Double-A team in Birmingham. There were five blacks on the 1964 team. The first integrated game at Rickwood was played without incident. Paul Seitz was the starting pitcher for Birmingham. The Birmingham A's would see a lot of very talented ball players come through Birmingham to feed the dynasty of the Oakland A's from 1970 to 1975. (Courtesy of Birmingham Chamber of Commerce.)

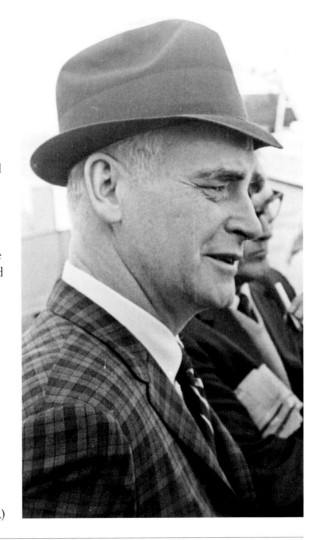

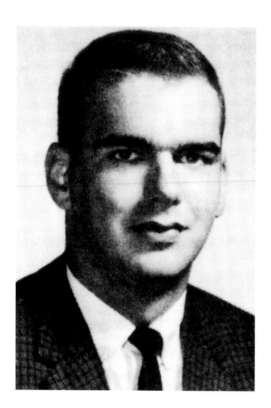

Paul Bryant Jr., son of the legendary Alabama football coach, was the general manager of the Birmingham Barons from 1964 to 1965. (Courtesy of Friends of Rickwood.)

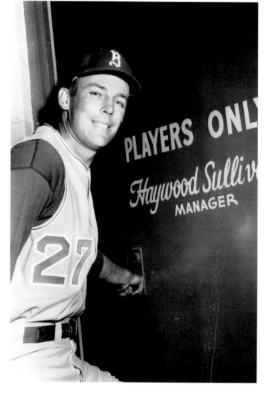

Former Boston Red Sox catcher Haywood Sullivan prepares to enter his new office as manager of the Birmingham Barons in 1964. Sullivan had retired after the 1963 season, having played the last three years with Kansas City. In 1965, he would replace Mel McGaha as Kansas City's manager. (Courtesy of Glynn West.)

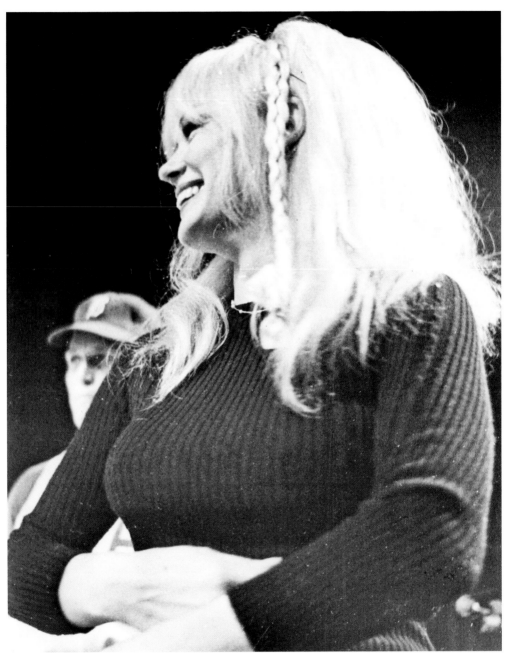

With the success of Marilyn Monroe, Universal Studios was looking for their own Monroe, and Mamie Van Doren was their choice. She made several B movies but was most remembered for the men she dated. She was once engaged to baseball player/playboy Bo Belinskey in 1962. Then in 1966, the 35-year-old actress married 19-year-old minor-league pitcher Lee Meyers. Meyers was the heir to the McCall's magazine fortune. He died tragically in a car wreck in 1972. Lee was the starting pitcher that night. He pitched the best game of his short career with Birmingham. (Courtesy of Birmingham Chamber of Commerce.)

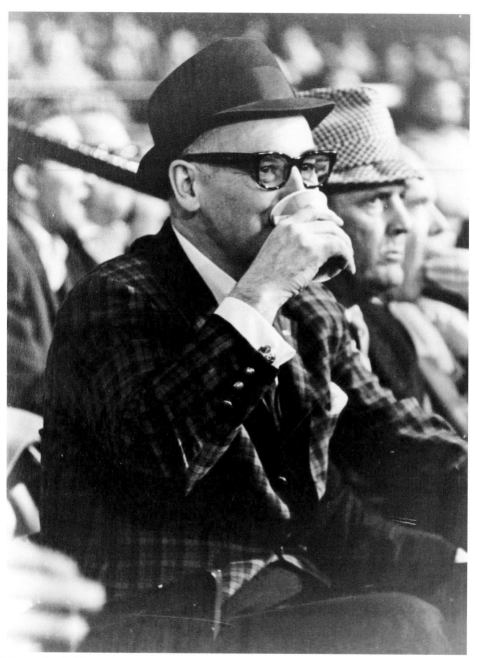

Alabama football coach Bear Bryant was a regular at Rickwood during the Finley era. He filled in for Mamie Van Doren on opening night, April 11, 1967, when Van Doren had to keep a commitment for a nightclub appearance. That night coach Bryant came to get his ticket, and the lady at the ticket window would not let him in. He was there to throw out the first pitch, and his son was the general manager of the Barons. Finally someone came out and "The Coach" finally got in. (The ticket lady must have been an Auburn fan.) (Courtesy of Birmingham Chamber of Commerce.)

CHARLIE O. TAKES OVER

John McNamara, the manager for the Birmingham Barons in 1965, was a catcher by trade. Signed by the St. Louis Cardinals in 1951, McNamara was like many managers and coaches of his time who never played a game in the majors but had success as a coach and manager. In an unusual move, Charlie Finley moved the team to Mobile in 1966 only to move the team back in 1967 with McNamara still the manager. John went on to have a very successful career as a major-league manager. (Author's collection.)

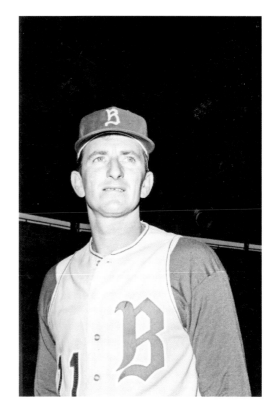

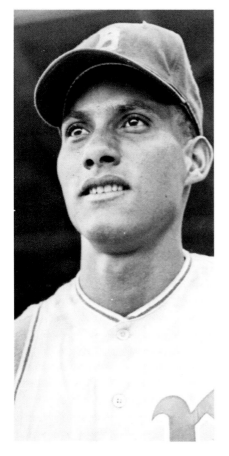

Bert Campaneris, a young Cuban shortstop, started the 1964 season with the Birmingham Barons. He was one of five black players on the first integrated professional baseball team in Birmingham. Due to his .325 average and 25 steals, Campaneris soon found himself with the parent club in the majors. At the end of the season, Bert was named to the *Sporting News* and Topps First Year All-Star team. (Author's collection.)

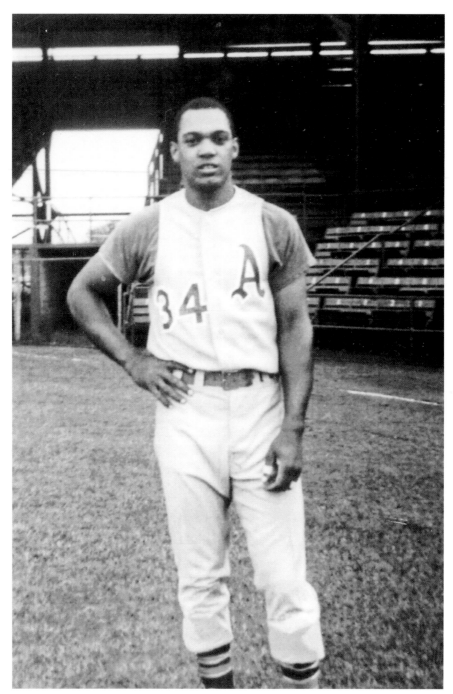

For 114 games in 1967, Reggie Jackson played for the Birmingham A's. His 17 home runs were good, but he also hit 17 triples, which was even more amazing. On several occasions, he hit mammoth home runs over the right-field stands at Rickwood. These home runs were just a prelude to his 1971 home run at the All-Star game in Detroit off Pittsburgh Pirates pitcher Doc Ellis. (Courtesy of Buddy Coker.)

CHARLIE O. TAKES OVER

Rollie Fingers's debut with the Birmingham A's was one he would probably just as soon forget. It was opening night in April 1967, and he was the starting pitcher. In the fourth inning, Fingers was hit in the face by a line drive. He was whisked to the hospital along with his tearful newlywed wife, Jill. (Courtesy of Birmingham Barons.)

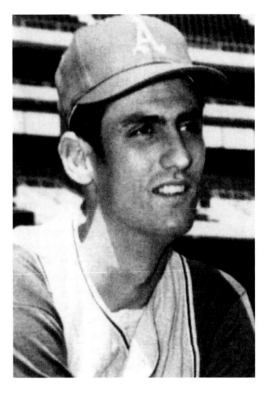

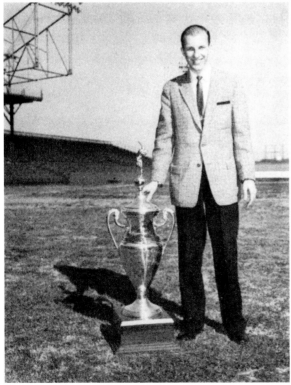

Glynn West began his baseball career as the scoreboard operator at Rickwood Field at the age of 16. When Eddie Glennon left to take the general manager position with the Atlanta team, West became the general manager of the Barons in 1964. At season's end, Glynn was named "Executive of the Year in Double-A" by the *Sporting News*. The first year back, Birmingham led the new Southern League in attendance. (Courtesy of Glynn West.)

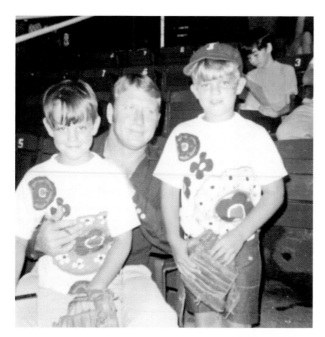

Mickey Mantle made several appearances at Rickwood Field in the mid-1950s in spring training games. This visit to Rickwood after his retirement may have come when his restaurant opened in Birmingham. The look on Mantle's face may reveal some discontent in becoming more of a sideshow, relegated to signing autographs and having his picture taken with children who never saw him play. (Courtesy of Friends of Rickwood.)

Dave Duncan (seen here) and Tony LaRussa met during their early days in minor-league baseball. They spent time together in 1965 and 1967 in Birmingham. Both players' impact on the game has come after their playing days were over. Tony LaRussa, as a future Hall of Fame manager, and Dave Duncan, his right-hand man and pitching coach, have traveled as a team, managing several major-league teams together. (Courtesy of Buddy Coker.)

CHARLIE O. TAKES OVER

Denny McLain made baseball history in 1968, becoming the first pitcher since Dizzy Dean in 1931 to win 30 games in a season. Within a few short years, his career had disintegrated and he was having legal problems. Coming to Birmingham was just one of his several comeback attempts. (Courtesy of Glynn West.)

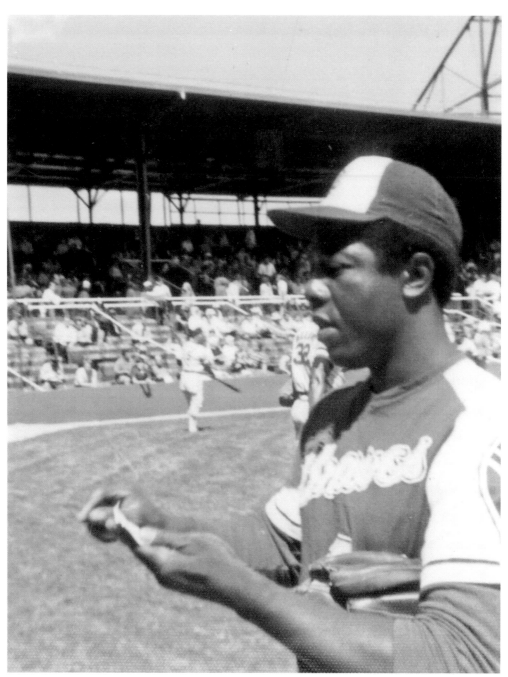

In 1969, the Atlanta Braves came to Rickwood to play the Southern League All-Stars, with Hank Aaron only having one official at-bat. His brother Tommie also played in the game. Even in 1969, there were probably few fans who would have remembered Aaron coming to Rickwood in the early 1950s as a member of the Negro League team the Indianapolis Clowns and playing shortstop. In 1970, Hank Aaron led the Braves to a 3-1 win over the Southern League All-Stars with two hits. (Courtesy of Buddy Coker.)

When Mamie Van Doren finally appeared to throw out the first pitch on April 27, 1967, Charles Finely was at Rickwood to act as her personal catcher. Despite all the hype, only 1,435 fans showed up for the promotion. (Courtesy of Birmingham Chamber of Commerce.)

Joe DiMaggio made a rare appearance at Rickwood Field as the hitting coach for the Oakland A's in the spring of 1968. The early afternoon game only attracted a crowd of 1,913. Joe only lasted two seasons as a coach with Oakland before returning to his Yankee roots. (Courtesy James Gamble.)

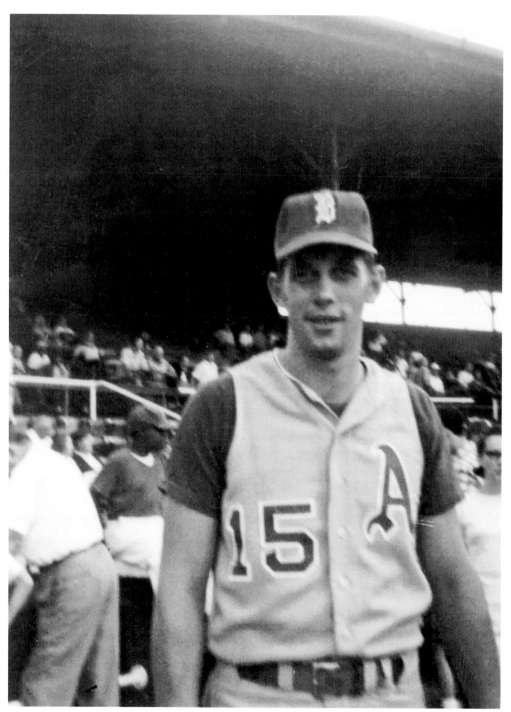

Joe Rudi was just one of the many cogs in the Oakland A's dynasty who came through Birmingham. It must have been exciting for baseball fans in Birmingham who had followed the A's to see their players be a part of three consecutive World Series championships that they helped build. (Courtesy of Buddy Coker.)

CHARLIE O. TAKES OVER

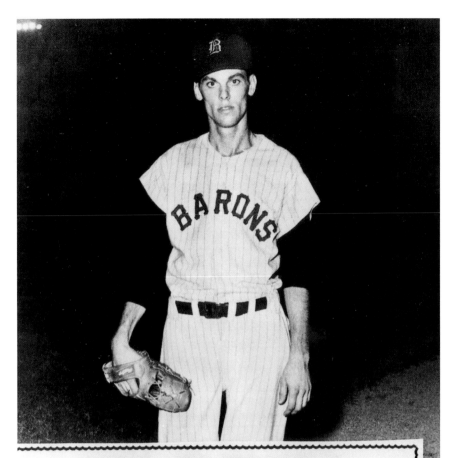

JOE GRZENDA

Set club record for most strikeouts by fanning 190 men in 1958. The previous record was set by Phil Morrison in 1922 at 170 strikeouts. Burleigh Grimes struck out 158 in 1915 for the next best record by a Baron.

In 1958, Joe Grzenda recorded 190 strikeouts, setting a new Barons record. This new mark was 20 more than the previous record. Grzenda was a nervous chain smoker with a very lively fastball. Ask an old Rickwood fan from the late 1950s and he or she will tell you, "No one threw the ball harder than Joe." He set down three batters in a row to close out the last game for the Washington Senators in 1971. After baseball, Joe returned to Scranton, Pennsylvania, to retire, and one of his neighbors was former Baron Stan Palys. (Courtesy of Friends of Rickwood.)

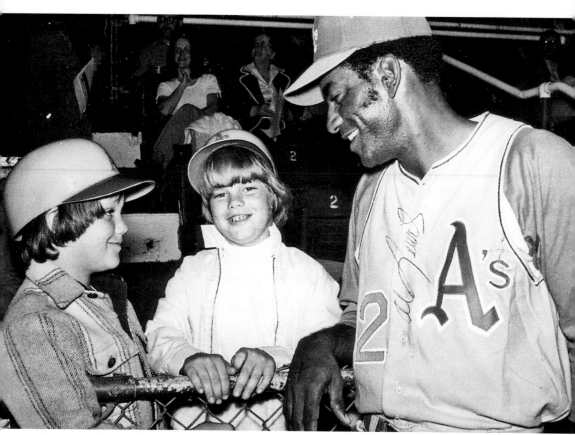

Longtime Birmingham A's player Allan Lewis chats with two admiring fans on free batting helmet night at the A's game. Lewis was from Panama and was known as the "Panamanian Express." His pro career began in 1961, and he played five years for Birmingham. His first year in Birmingham was 1967. In 1968, he stole a career-high 46 bases but afterward his speed quickly diminished, and in his last year of baseball in 1973 with Birmingham he had no steals. (Courtesy of Friends of Rickwood.)

CHARLIE O. TAKES OVER

BASEBALL RETURNS
TO RICKWOOD

The A's left Birmingham for good after the 1975 season, and a loyal fan base longed for the return of minor-league baseball, which was enjoying a resurgence across the country. Memphis brought back the Chicks to the Southern League in 1978 to large crowds. Part of the success of the Chicks was due to general manager Art Clarkson and his knack for promotions. Birmingham businessman Jack Levin headed a group that contracted Clarkson to come to Birmingham to bring baseball back to the Magic City. And he did just that. This program cover says it all after a five-year absence. Southern League baseball had returned to Rickwood Field and Birmingham. (Author's collection.)

SOUVENIR PROGRAM — $1.00

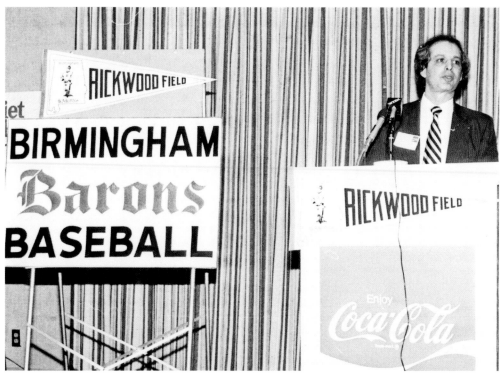

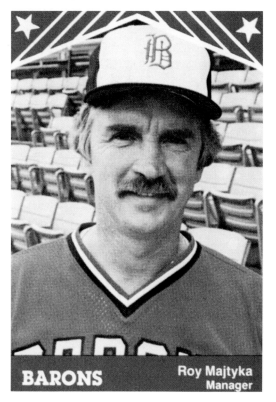

In 1980, a small group headed by Jack Levin wanted to bring baseball back to Rickwood after a five-year absence. Levin asked Memphis Chicks general manager Art Clarkson to help him make that happen. In 1981, the Birmingham Barons returned to Rickwood Field and the Southern League. Clarkson brought baseball back to stay in Birmingham and helped orchestrate the Barons' move to Hoover in 1988. Clarkson is shown here at an early news conference talking about the Barons' return to Birmingham. (Courtesy of Birmingham Barons.)

When the Barons returned to Rickwood Field in 1981, Roy Majtyka was named manager. Roy was the manager of Montgomery in 1980. He would lead the Barons to a second-place finish in their first season back since 1975. (Courtesy of Chuck Stewart.)

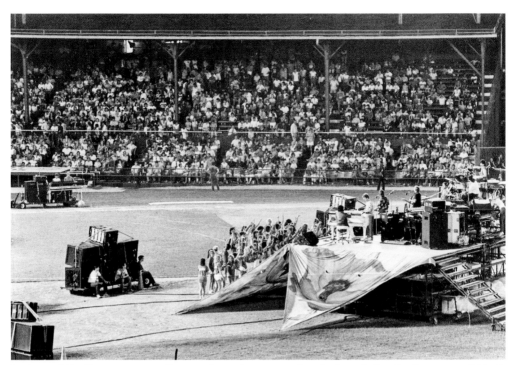

Rickwood Field was more to Birmingham than just a baseball park for the Barons and Black Barons. The Industrial and City Leagues also played baseball there. The University of Alabama, Auburn University, Howard College, and Birmingham-Southern College played football games at Rickwood until Legion Field was completed about 1928. It also hosted the circus, and from the 1960s through the 1980s music concerts were a regular feature. These pictures show a 1985 Beach Boys concert at Rickwood Field. (Both courtesy of Birmingham Barons.)

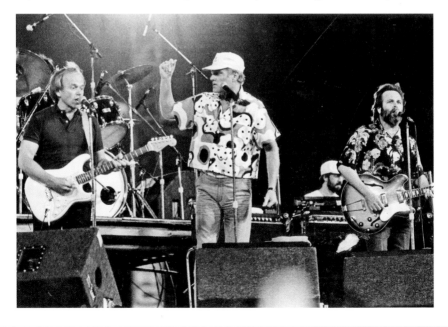

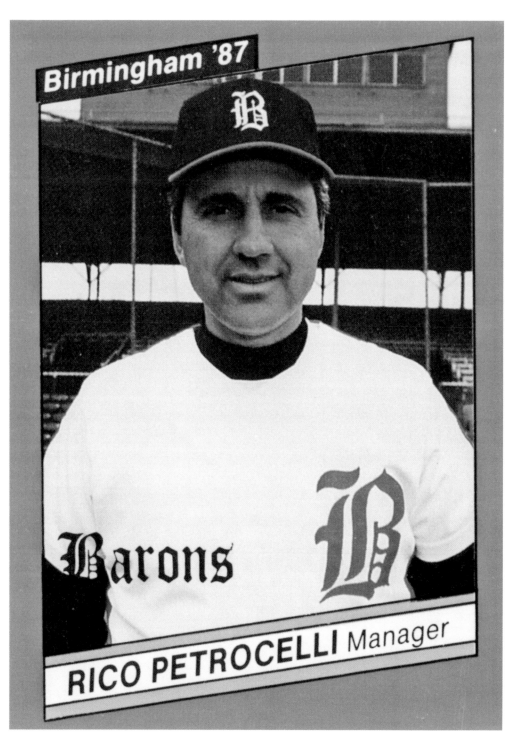

Birmingham '87

RICO PETROCELLI Manager

Rick Petrocelli has the unique distinction of being the last manager of the Barons at Rickwood Field and also the first manager for the Barons at the Hoover Met. Petrocelli's 1987 team won the Southern League championship. (Courtesy of Birmingham Barons.)

Barbaro Garbey was one of the first Cuban defectors to play major-league baseball. He was part of the mass migration of Cubans by any small boat they could find to make the dangerous trip across the straits from Cuba to Key West. Garbey played two years for Birmingham and then played for the Detroit Tigers. He finished his career in the Mexican League and is now a hitting coach for a minor-league team. (Courtesy of Birmingham Barons.)

The year 1987 would be the Barons' last one at Rickwood Field. The Barons won the first half but then finished fifth in the second half. The Barons would go on to win the championship partly because of the home-run hitting of Rondal Rollin. Rollin hit 39 homers to break Norm Zauchin's single-season record, one that went back to 1950. (Courtesy of Birmingham Barons.)

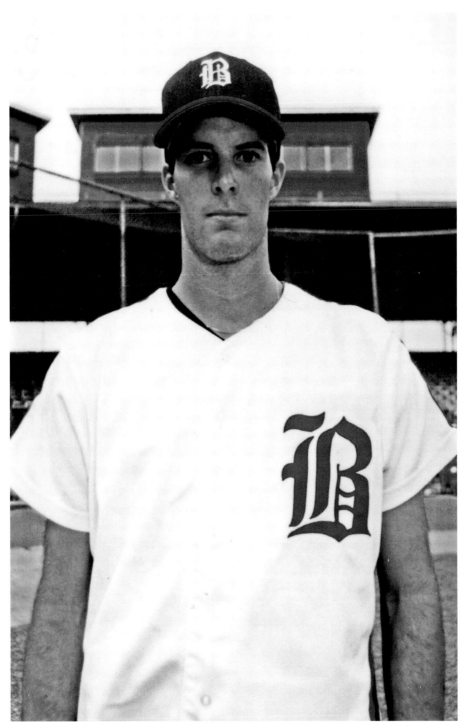

Jack McDowell only had four starts for the 1987 Barons. He will be remembered as the last starting pitcher in the playoffs at Rickwood Field on September 9, 1987. Jack would go on to win the 1993 Cy Young Award with the Chicago White Sox. (Courtesy of Birmingham Barons.)

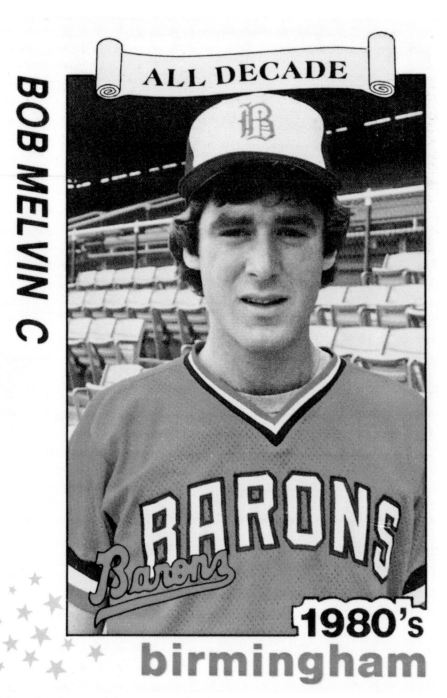

ALL DECADE

BOB MELVIN C

1980's
birmingham

Bob Melvin played parts of three seasons for the Barons from 1982 to 1984. Melvin spent his entire major-league career as a back-up catcher for several teams. In 2005, he became manager of the Arizona Diamondbacks after Wally Backman, a former Barons manager. Backman was fired from the Diamondbacks before managing even one game because of an issue with past arrests and financial problems. (Courtesy of Birmingham Barons.)

Mike Yastrzemski, son of Carl Yastrzemski, the Hall of Fame Boston Red Sox outfielder, joined the Barons on the last day of spring training in 1986. Mike hit a home run in his first at-bat for the Barons in a spring-training game against the White Sox. He had a good season for the Barons, hitting 12 home runs and batting .285 with 73 runs batted in. (Courtesy of Birmingham Barons.)

The 1981 Barons were loaded with promising, talented players who would make it to the majors: Glenn Wilson with the Detroit Tigers, Philadelphia Phillies, Seattle Mariners, Pittsburgh Pirates, and Houston Astros; Howard Johnson with the Tigers, New York Mets, Colorado Rockies, and Chicago Cubs; Mike Laga with the Tigers, St. Louis Cardinals, and San Francisco Giants; Barbaro Garbey with the Tigers and Texas Rangers; and Dwight Lowry with the Tigers and Minnesota Twins. (Courtesy of Birmingham Barons.)

BASEBALL RETURNS TO RICKWOOD

THE MOVE
TO THE SUBURBS

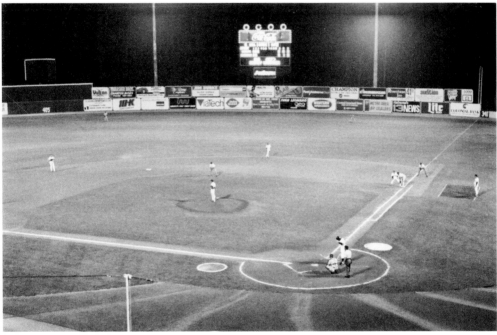

Art Clarkson had done a great job of bringing baseball back to Birmingham, but Rickwood provided challenges he could not overcome. After a few years, the attendance started to decline. The ballpark was now 75 years old and in constant need of maintenance and upgrade. Limited parking forced fans to park in the neighborhood, which could be risky. Birmingham city officials turned a deaf ear to Art and his concerns. Despite his love for the old park, Clarkson began to shop around for a new location in the Birmingham metro area to provide a home for the Barons. Hoover, Alabama, south of Birmingham, gave Clarkson what he needed, a ballpark in an affluent suburb with a brand-new, state-of-the-art ballpark and plenty of parking. On August 30, 1987, the Barons played their last game at Rickwood Field. The complete demise of Rickwood Field could not be far behind. (Courtesy of Birmingham Barons.)

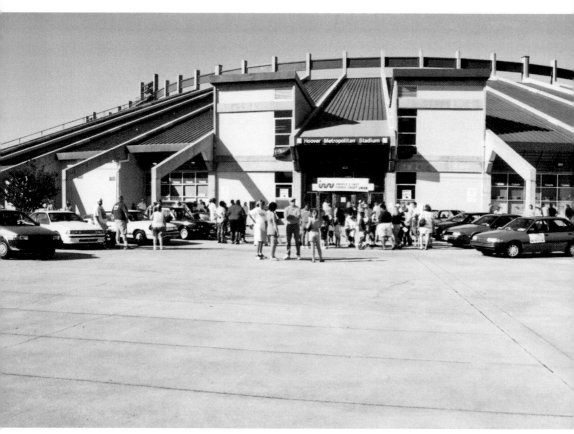

The year 1988 would be a new era for baseball in Birmingham. Rickwood Field would not be the site of a professional game again until the first Rickwood Classic in 1996. The Hoover Metropolitan Stadium opened to its first game on April 16, 1988. The Barons won the first game 8-2 against the Greenville Braves. The new stadium had over 10,000 seats, could hold over 16,000 fans, and had 4,000 parking spaces. The Barons had to keep up with the demands of baseball in these modern times, while Rickwood Field waited to be rediscovered. (Courtesy of Birmingham Barons.)

THE MOVE TO THE SUBURBS

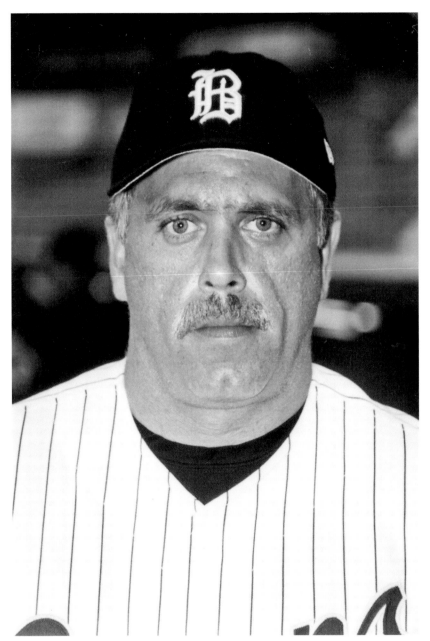

Wally Backman became manager of the Barons in 2002. He managed the same way he had played the game as the New York Mets second baseman—a scruffy player who would bunt, hit and run, and play good defense. The fans in Birmingham called his style of managing "Wally Ball," and they loved it. Backman promised at the beginning of the season that the team would run and run. The 2002 Barons were not made up of can't-miss prospects but good chemistry, aggressive play, and a good bullpen; these were their strengths. The 2002 championship was the first for the Barons since 1993. The championship win was even sweeter because the final victory was at home at the Hoover Met. (Courtesy of Birmingham Barons.)

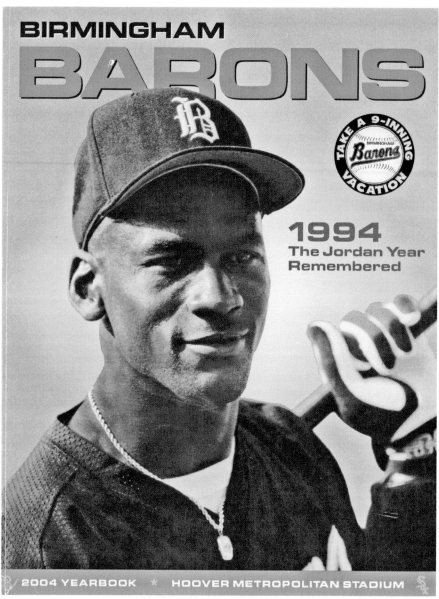

BIRMINGHAM BARONS

TAKE A 9-INNING VACATION

BIRMINGHAM Barons

1994
The Jordan Year
Remembered

2004 YEARBOOK ★ HOOVER METROPOLITAN STADIUM

Michael Jordon shocked the basketball world when he retired from the game. A second shock went out when he said he wanted to become a professional baseball player. An unbelievable season kicked off on March 31, 1994, when Jordon was assigned to the Barons roster. In 1994, the Barons set a new attendance record of 467,867. Barons road games also drew large crowds. Jordon only hit .202 for the season, but that did not stop the excitement his presence created. Adding to the mystique, the Barons introduced the Jordon Cruiser, a state-of-the-art motor coach for the whole team. Despite all the hype surrounding it, Michael Jordon did not buy it for the team. During the season, three games were televised nationally, an unheard-of event for a minor-league team. Jordon's final home game set a Hoover Met record crowd of 16,247. Michael retired from baseball the next spring and returned to basketball. (Author's collection.)

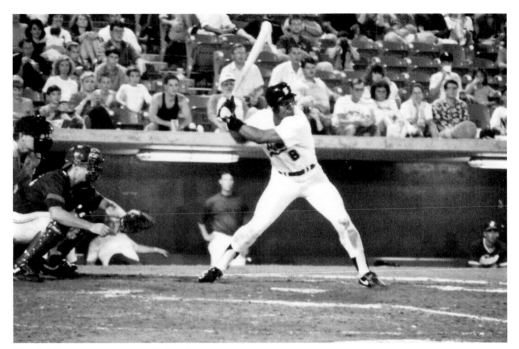

Frank Thomas grew up in Columbus, Georgia. He attended Auburn University, playing both football and baseball. In 1990, playing for the Barons, Frank was named Minor League Player of the Year. There are only six players in major-league history who have both hit more home runs and have a higher batting average than Frank. (Courtesy of Birmingham Barons.)

In 2005, Don Logan, with his two sons Jeff and Stan, purchased the Birmingham Barons. Don had attended Barons games growing up. His career with Time Warner moved him to New York in 1992, but since 2006 Don and his family are back in the Birmingham area. Those who go to Barons games regularly will see Don and his sons walking around greeting fans and watching the game with their families. (Courtesy of Birmingham Barons.)

Every boy's dream is to be the batboy for the local professional baseball team. Greg Paiml was the batboy for the Birmingham Barons for two years. After high school, Paiml was a four-year starter on the University of Alabama baseball team and then was drafted in the 15th round by the Chicago White Sox. This year, 2009, he is playing for the Winston-Salem team, and next year hopefully he will be here in Birmingham, playing for the same team he was a batboy for many years ago. (Courtesy of Roger Paiml).

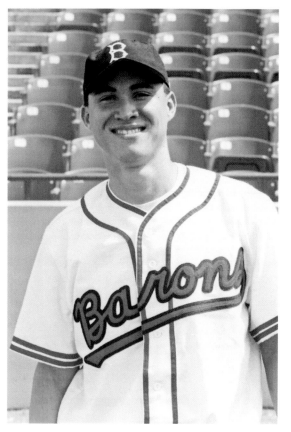

Magglio Ordóñez is one of those players who did not impress the fans as he came through Birmingham. He showed some power in his bat, but he did not hustle in the outfield. Regardless, he has become a major star both in Chicago and now with Detroit. (Courtesy of Birmingham Barons.)

THE MOVE TO THE SUBURBS

Craig Grebeck was a fan favorite at the Barons' new home in 1988 at the Hoover Met. Grebeck was responsible for the first RBI at the new ballpark on April 16, 1988. The Barons won the game 8-2 before 13,279 fans. (Courtesy of Birmingham Barons.)

Jim Abbott, a one-armed left-handed pitcher, had accomplished some amazing things in amateur baseball by 1998. He was an outstanding college pitcher at the University of Michigan, and he pitched the final game of the 1988 Olympics. He then went straight to the major leagues without playing one minor-league game. His eight years in the majors included a no-hitter with the Yankees in 1993. He sat out in 1997 and tried to make a comeback in 1998 with the Barons. His comeback would be unsuccessful, but watching him field his position was worth the price of admission. (Courtesy of Birmingham Barons.)

Playing for the Birmingham Barons in 1991 was like coming home for Bo Jackson. The high school he attended was 10 minutes from the Hoover Met. After a serious hip injury in a 1991 National Football League football game, Bo attempted to rehabilitate his hip and continue his baseball career. Bo worked his way back to the majors with the Chicago White Sox, but he was primarily a designated hitter after the hip injury. One can only dream about what Bo Jackson could have accomplished had he only played baseball. (Courtesy of Birmingham Barons.)

Terry Francona managed the Barons for three years from 1993 to 1995. He is remembered most for being the manager in 1994, the year Michael Jordon was a Baron. Francona was the son of former major-leaguer Tito Francona. Terry would go on to fame as the manager of the world champion Boston Red Sox. (Courtesy of Birmingham Barons.)

One of the most memorable moments about the Birmingham Barons' 1996 season was Pete Rose Jr. playing third base for the Barons. Pete Jr. had been seen throughout his father's career; he was the batboy at Cincinnati Reds games, he appeared on a baseball card with his dad, and every baseball fan should remember Pete and Pete Jr. sharing a hug when Dad broke Ty Cobb's career hit record. Unfortunately Pete Jr. did not have his father's fire and passion for the game. In 1997, he did get to play 11 games with Cincinnati and then went back to the minors for seven more years. (Courtesy of Birmingham Barons.)

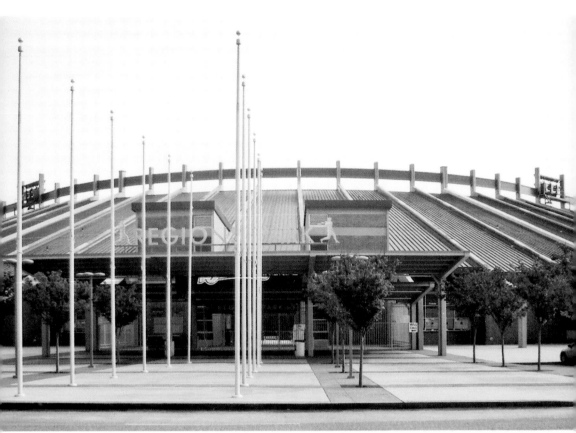

Before the start of the 2006 season, the Hoover Met began a series of renovations to completely modernize the stadium. Improvements included a state-of-the-art video scoreboard, a new irrigation and drainage system, new box seats, a new facade, a new front entrance, and a second deck added to the press box area. In 2007, the Hoover Met was renamed Regions Park, a new name to go along with the newly renovated ballpark. (Author's collection.)

Robin Ventura only played one year in the minors, and that was 1989 with the Barons. He hit .278 with 67 RBIs and was selected as a Southern League All-Star. He was also voted Southern League top defensive third baseman. Robin played his college baseball at Oklahoma State University. In 1987, Oklahoma State lost the College World Series to Stanford University and their pitcher Jack McDowell, also a former Baron. (Courtesy of Birmingham Barons.)

THE MOVE TO THE SUBURBS

The Friends of Rickwood and the Classic

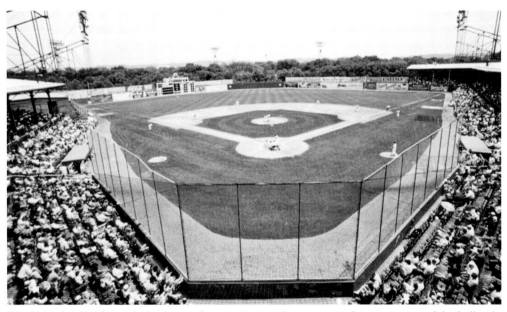

The Friends of Rickwood, the nonprofit organization that oversees the restoration of the ballpark, began as the dream of three men: Coke Matthews, Tom Cosby, and Terry Slaughter. The ballpark was a mess; the roof was falling in, and the outfield walls were crumbling. They all agreed that Rickwood should not go the way of the wrecking ball, like Comiskey Park. The Alabama film commission contacted Terry about making a movie about Ty Cobb at Rickwood. The group enlisted the help of Mayor Richard Arrington and others to get needed repairs. At the same time, the film company agreed to make improvements. The filming of Cobb jump started the restoration and created positive publicity. Baseball fans came out to Rickwood for the first time in years to be extras in the film. The exposure of Rickwood to the movie industry led to a second baseball movie, the HBO movie *The Soul of the Game*. The second great achievement of the Friends of Rickwood was the Rickwood Classic. Everyone involved saw the potential for such an event, and in 1996 the first annual Rickwood Classic was played before a crowd of over 10,000. The Friends of Rickwood has become the model for cities seeking to save their old baseball parks. (Author's collection.)

Chris Fullerton was the first executive director of the Friends of Rickwood. Tragically Chris was killed in an automobile accident in 1997. He did leave a lasting legacy when close friends and associates revised his 1994 master's thesis into the book *Every Other Sunday*, the story of the Birmingham Black Barons. (Courtesy of Friends of Rickwood.)

A. H. "Rick" Woodward III speaks to the history of Rickwood Field during the ground-breaking ceremonies for the new baseball museum that will be built in the parking area next to Rickwood Field. The museum will house the Negro League collection of Dr. Layton Revel and artifacts from Rickwood Field and the Southern League. (Author's collection.)

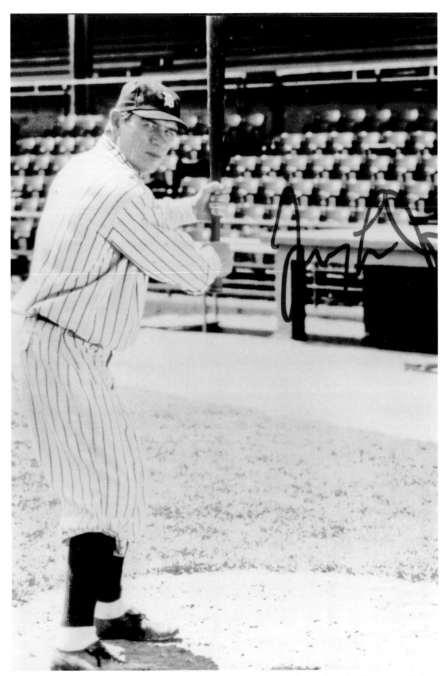

In the 1990s, Hollywood produced several period movies about baseball. Two of these were filmed at Rickwood Field, the Ron Shelton movie *Cobb* and the HBO movie *The Soul of the Game*. In *Cobb*, Tommy Lee Jones played the part of Ty Cobb, with most of the baseball scenes shot at Rickwood Field. These movies had several benefits for the ballpark: extra income, park improvements, and publicity. Several commercials were also filmed at Rickwood during this time period. (Courtesy of Friends of Rickwood.)

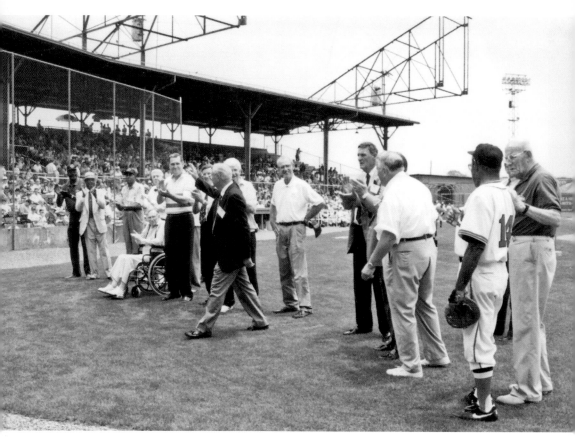

A select group of local baseball legends were recognized at the first Rickwood Classic—players who made the plays and hit the home runs recounted in stories about Rickwood. Those present included Norm Zauchin (Barons 1950), Elijah Gilliam (BBB), Bill Powell (BBB 1946–1950, 1952), Walt Dropo (Barons 1948), Bill Greason (BBB 1948–1951), Fred Hatfield (Barons 1949–1950), Jimmy Bragan (Chicks 1953, Bears 1954, Vols 1956), Luman Harris (Crackers 1937–1940), Bubba Church (Phillies 1950–1952), and Piper Davis (BBB 1942–1950). (Courtesy of Chuck Stewart.)

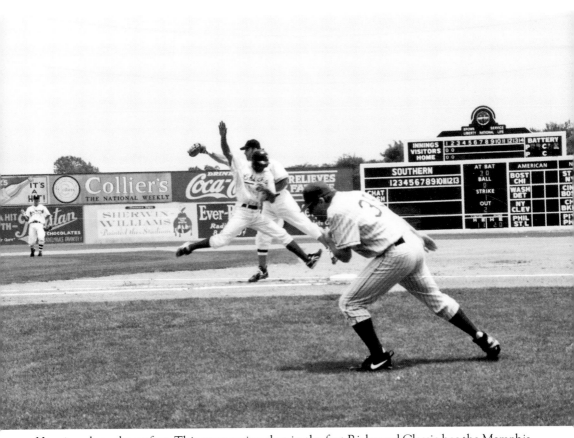

Here is a close play at first. This great action shot in the first Rickwood Classic has the Memphis Chicks playing Birmingham. The Memphis runner looks like he will be safe as the throw pulls the first baseman off the bag and sends the first-base coach ducking for cover. (Courtesy of Church Stewart.)

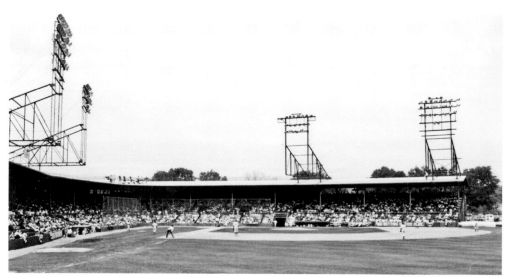

This shot from the outfield from one of the first Rickwood Classics is without the familiar gazebo. All the old press boxes that had been built over the years were removed because of the need to replace the roof. The gazebo would later be rebuilt to 1910 specifications. (Courtesy of Chuck Stewart.)

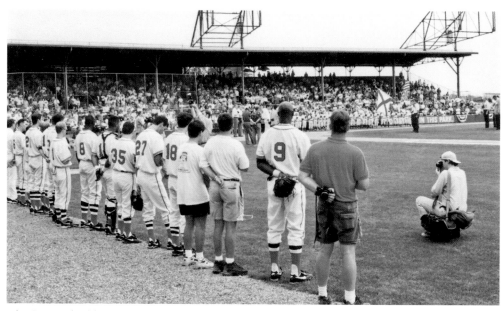

The Barons had been gone for nine years. The concept of a "Turn Back the Clock Game" was being considered by several different interested parties. Bill Hardekopf, general manager of the Barons, saw the potential benefits of such a game early. The Friends of Rickwood, with the help of the Slaughter Advertising Group, came up with the name and theme concept. Each game would have a theme, honoring a particular era of baseball at Rickwood. The first one in 1996 was a resounding success, with attendance of over 10,000. This ensured that there would be Rickwood Classic in the future. (Courtesy of Chuck Stewart.)

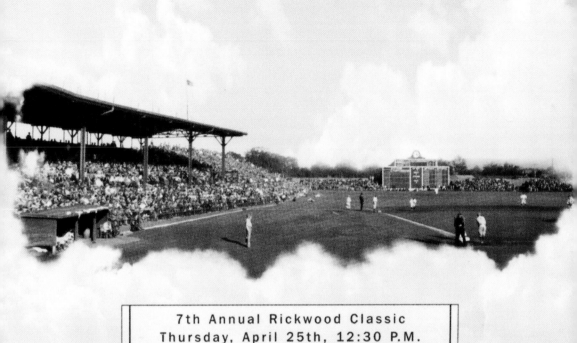

7th Annual Rickwood Classic
Thursday, April 25th, 12:30 P.M.

Probably the favorite Rickwood poster ever made was this "Field of Dreams" poster for the seventh classic in 2002. The poster portrays the 1929 Dixie Series in the clouds. In truth, Rickwood Field is a field of dreams—the dream of every city that demolished its old ballpark only to regret it years later. (Courtesy of Friends of Rickwood.)

From left to right, a fan talks baseball with Bobby Bragan and Frank Lary in the conference room at the 2007 Rickwood Classic. Bragan was a former major-league catcher and manager and part of one of Alabama's premier baseball families. Lary, from Northport, Alabama, played for the Detroit Tigers and was known as the "Yankee Killer" because of his knack for beating the Yankees when he pitched against them. (Author's collection.)

Viewing the field after the classic, everything that is missing from baseball today can be seen. Fans are casually walking around the field talking baseball. A few of the players are staying around to sign autographs, as it should always be. A small boy is playing catch with his dad. Some fans are walking out to the outfield wall, just to touch it, like it is the Wailing Wall in Jerusalem. A man stands on the pitching mound with his hand on his grandson's shoulder, telling him about a precious memory of his days at Rickwood. Children are making their own memories as they run the bases. Photographs are being taken. A young man stands in right field and briefly crouches into the fielder's position ready to catch a line drive. He could be thinking about all the great players who stood on that very spot. Truly Rickwood is the Field of Dreams. It reminds people that there once was a time when guards did not circle the field after a game, when fans and players were equals. Rickwood allows everyone, for one brief afternoon, to remember all that was right and good about baseball. (Author's collection.)

DISCOVER THOUSANDS OF LOCAL HISTORY BOOKS
FEATURING MILLIONS OF VINTAGE IMAGES

Arcadia Publishing, the leading local history publisher in the United States, is committed to making history accessible and meaningful through publishing books that celebrate and preserve the heritage of America's people and places.

Find more books like this at
www.arcadiapublishing.com

Search for your hometown history, your old stomping grounds, and even your favorite sports team.

Consistent with our mission to preserve history on a local level, this book was printed in South Carolina on American-made paper and manufactured entirely in the United States. Products carrying the accredited Forest Stewardship Council (FSC) label are printed on 100 percent FSC-certified paper.

MADE IN THE
USA